Painting in Acrylics

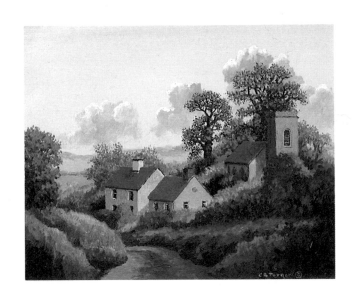

The authors

Gordon Davies studied at Camberwell College and at the Royal College of Art. An artist and craftsman with a wide knowledge of the decorative arts and architecture, his varied accomplishments have led him into fabric and wallpaper design, terracotta and china modelling, silver-work and glass engraving. In recent years he has constructed a number of decorative features in private houses in this country and abroad, and has been commissioned for murals in the Centre for European Agricultural Studies at Wye and at Wolfson College, Cambridge.

Since 1951 Gordon Davies has exhibited regularly at the Royal Academy and held several one-man shows in London and elsewhere. He lives in Kent.

Wendy Clouse trained at the El Paso Academy of Arts in Texas, and studied further at the City College of Chigaco, and the University of Maryland. She has had many one-woman shows in England, as well as the U.S. and Germany; and her work is in collections in many parts of the world.

She has spent much time travelling around England demonstrating painting, and has made four instructional videos, two on watercolour, one on acrylic landscape and the last one, backed by Rembrandt Paints, on pastel painting. She has written a book entitled *Art School Step by Step – Acrylics* and has also published several articles in magazines including *The Artist and Illustrator* for which she composed a four-page demonstration on painting children in watercolour.

She lives in Walton-on-Thames in Surrey, where she teaches painting classes as well as working on her own paintings.

Ray Campbell Smith FRSA, is a professional painter who works in acrylics, oils and watercolour. More than thirty one-man shows have been held in the galleries which handle his work, and he is represented in private and public collections throughout the world. As well as contributing regularly to *The Leisure Painter* magazine, he gives frequent lectures, demonstrations and criticisms to art groups and painting courses. He has also made four instructional videos for Seeba Film Productions.

He has been commissioned to make paintings of famous buildings including Guildford Cathedral (for presentation to the Duke of Devonshire), Knole House, (for Lord and Lady Sackville), Chartwell, Gresham's School, Sevenoaks School and many other stately homes, churches and schools.

In 1988 he was elected a Fellow of the British Society of Painters and is a member of the British Watercolour Society.

Wendy Jelbert studied sculpture, abstract art, pottery and printmaking at Southampton College of Art. She is a teacher and a professional artist who works in pastels, oils, acrylics and watercolour. She enjoys experimenting with different ways of using mixed media and texture and her unconventional methods often produce surprising and original results. She is married, lives in Nether Wallop, Nr Stockbridge and has three children, two of whom are studying art.

Galleries in Southampton, London, Brighton, Bath and Cornwall regularly exhibit her work and she has had several articles published in *The Leisure Painter*. She is a member of the Society of Women Artists.

Cyril B. Turner, MAA, is one of Britain's leading and most experienced fine art master miniaturists and among the world's best. For the past twenty years he has devoted all his time to miniature fine art, working exclusively in miniature, producing paintings in most media and categories.

His greatest asset is his gift in the fundamental art of miniaturism. He creates beautiful, original miniatures without the use of any photographic or mechanical equipment.

His contributions to original fine art miniature painting include the development of a soft pastel technique, which enables intricately detailed miniatures to be produced down to a size of 1 cm (½ in) square. A few years ago he introduced cold enamel as a medium for miniature painting.

Over the past ten years, thirty five of his miniatures have won awards, including eleven international firsts. Seven were painted in acrylics, and awards in other media include oils, cold enamel, gouache and illuminated calligraphy, watercolour and soft pastel.

He was the first non-American to be honoured by election to the Miniature Artist's of America, and is a member of the Australian Society of Miniature Art.

Painting in Acrylics

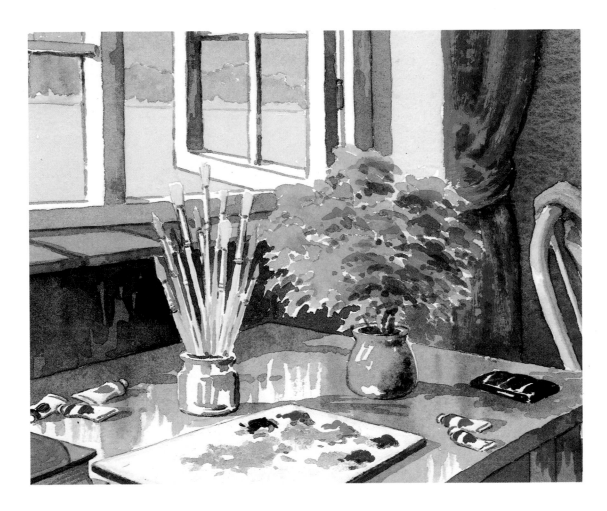

Gordon Davies Wendy Clouse
Ray Campbell Smith Wendy Jelbert
Cyril Turner

SEARCH PRESS

First published in Great Britain 1991
Search Press Ltd
Wellwood, North Farm Road
Tunbridge Wells, Kent TN2 3DR

Based on the following volumes of the Leisure Arts series published by Search Press, Tunbridge Wells:

Painting landscapes in acrylics by Wendy Clouse
Waterscapes in acrylics by Ray Campbell Smith
Still life in acrylics by Ray Campbell Smith
Painting flowers in acrylics by Wendy Jelbert
Textures in acrylics by Wendy Jelbert
Painting miniatures in acrylics by Cyril Turner

Copyright © Search Press Limited 1991

ISBN 0 85532 660 3

Publishers' note
There is reference to "sable" hair and other animal hair brushes in this book. It is the Publishers' custom to recommend synthetic materials as substitutes for animal products wherever possible. There are now a large number of brushes available made of artificial fibres and they are just as satisfactory as those made of natural fibres.

Phototypeset by Scribe Design, Gillingham, Kent
Made and printed in Spain by A. G. Elkar, S. Coop.
Autonomía, 71 - 48012-Bilbao

CONTENTS

Introduction

For the amateur painter acrylics are an excellent medium on which to start, for they are simpler to use than oil paints or watercolours and they combine many of the best qualities of these media while having unusual characteristics peculiar to themselves.

To begin with they are water-based, which enables brushes and mixing palettes to be washed under the tap and obviates the need for strong-smelling solvents.

They are extremely versatile. Although they have similarities with oil, watercolour and tempera, one of the most important of their unique characteristics is the speed with which they dry.

Another, and one of their most delightful qualities, is the way in which they can be laid down in a transparent wash or glaze on top of another colour. By using overlapping and different coloured glazes very rich effects can be achieved. Try, for instance, alternating glazes of warm and cool colours, ultramarine over burnt sienna, or vice versa; and try using glazes over opaque or heavily impastoed paint. Acrylics are excellent used in the latter manner precisely because they dry so rapidly.

Heavily applied oil paint can take a long time to dry out and the consequent disadvantages are that the surface can easily be damaged and is liable to collect dust and dirt during the drying process. Acrylic paints, squeezed directly from the tube, and applied as such, will be quite dry within a few hours. Mistakes can be quickly remedied by painting over the area containing the error. If you do this with oils it is messy – and with watercolours it is almost impossible.

These quick-drying properties are occasionally a disadvantage. When working in the open, particularly if the weather is sunny and hot, they can dry too quickly, both on one's painting surface and on one's mixing palette, and it is all too easy for particles of dry paint to get in the way. One of the solutions to this problem is more rapid work, which may impart greater freshness and punch to your paintings; another is the use of a water spray and retarding agent, which help the paint to remain workable for much longer.

Acrylics can also be used very much like watercolours. They can be diluted with water to produce washes and they have the advantage of allowing the artist to lay one wash over another without disturbing the previous one. However, the waterproof nature of the paint can be a disadvantage if one likes to wash paint out, as some watercolourists do. When dry it forms a rubbery film which is impervious to water and so colours cannot be lifted out with a damp brush as they can with watercolours. This film is very tough, adheres well and is resistant to fading. Unlike watercolours, which become lighter in tone on drying, acrylics become appreciably darker and due allowance needs to be made for this.

Although acrylics may be used to resemble either oils or watercolours, there are many variations between these techniques and it is these that give acrylics their individual character.

The versatility of these paints makes them attractive to artists. They can be used on almost any dust-free, grease-free surface, including hardboard (masonite), paper or canvas. There are various other media available which can be added to the paints for special purposes: gel medium for impasto work; a gloss and matt medium for increasing flow and transparency; textured effects can be created using masking fluid and other materials; gloss and matt varnishes can be applied to finished paintings. By experimenting you will discover which of these, if any, will help your work.

A variety of subjects are covered in this book, with step-by-step demonstrations providing an explanation of all the techniques required to produce a finished painting. By following these demonstrations you will gradually gain confidence and will soon learn to develop your own skills and style.

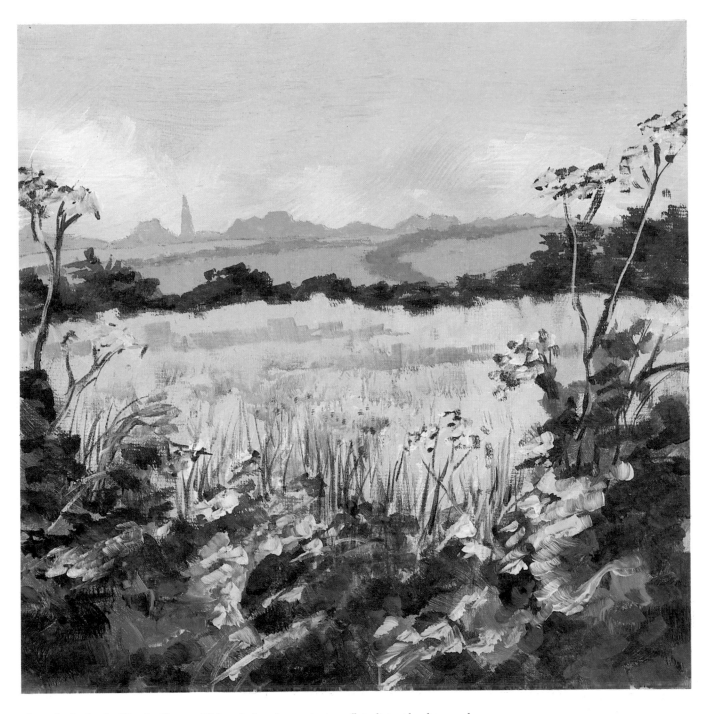

Over the hedge by Wendy Clouse. This painting demonstrates a flat, distant background in contrast with a very detailed foreground. The background colours merge into the distance while brighter colours are painted into the foreground. Perspective in landscape painting is discussed on page 24.

Materials

When you are choosing paints, brushes and other materials, always buy the best quality available. The difference in price is not usually great, but the difference in quality is enormous.

Surfaces

Acrylic paints can be used on many different types of dust-free or grease-free surfaces, and they need less elaborate preparation than oil paint (see also the exercises on pages 12 and 13). Wood panels, plywood, canvas of different grades, hardboard, paper and card are all eminently suitable and the paint can, if desired, be applied without any priming. Porous materials can be sealed with acrylic gesso primer to produce a good white painting surface. For mural painting the paint can be applied directly on to a sound plaster surface.

Most fabrics will take acrylic paint well, which can be of great help when making theatrical costumes. The decoration painted on to the fabric will adhere well and, because the paint remains pliable when dry, there is no danger of it cracking off when the costume is being worn.

When you paint on to very smooth surfaces, such as hardboard or metal, it is a good idea first to roughen the surface with sandpaper before applying primer. When painting on to paper it is best to use a fairly stout paper, especially if you plan to use the paint thickly or over a primer. When using thin acrylics any good watercolour paper without priming is suitable.

Brushes

The best brushes are made of hog-hair or sable and, if looked after carefully, will last much longer than cheaper substitutes. There are now a large number of brushes available made of artificial fibres, and they are just as satisfactory as those made of natural fibres.

You will need a mixture of flats, rounds and filberts, the size and shape depending upon the scale and style of your work. You will also require a couple of small sables for detailed work. Hog-hair brushes are generally used for applying thicker paint; softer brushes like ox-hair, squirrel-hair and sable are used for thinner applications of paint and are suitable for the watercolour technique.

Palette knives

A palette knife is an essential piece of equipment for mixing paint and cleaning the palette. Small flexible painting knives can be used with acrylic paint, but this is a technique with which the painter needs to experiment. Painting knife work can be attractive, though it demands a generous amount of paint to be effective and in the early stages this can prove expensive.

Paints

It is good practice to stick to a limited palette as this tends to give one's work a unity which the employment of a wide range of colours can easily destroy. It also makes it easier to get to know the individual properties of the chosen tubes more thoroughly, though this aspect is perhaps less important than it is with watercolour where the handling characteristics of different colours can differ considerably.

Various manufacturers make between them a range of different consistencies of acrylic paint. The standard paint has roughly the same consistency as oil paint; the thinner the acrylic the more liquid it is and this is especially useful if a flat even layer of paint is required.

Experiment with the paints to find out which suits your technique the best and the type of work you want to carry out.

Palettes

Plastic or wooden palettes are normally used for acrylic painting, but tear-off disposable palettes are also available and these are useful for outdoor work. If you like to keep things simple, any smooth, impervious surface will do. A pottery or porcelain surface is easy to keep clean. If the paint does become dry, just soak the plate in hot water.

Also available from most art suppliers are palettes that stay wet. These keep the paints moist while working. You could make your own 'wet' palette quite easily using an old dinner plate. Cut six layers of kitchen roll to fit, then place them on the plate. Wet the layers of paper thoroughly, remove the excess water, then place a piece of greaseproof paper over the top.

Small amounts of paint can now be placed on the greaseproof paper, and they can be mixed on this surface using an old paintbrush. The colours will not dry as long as the kitchen roll is kept moist.

Other materials

Acrylic gel can be mixed with the paint. This is available in a tube and resembles a jelly-like tooth-paste. It helps to 'bulk up' the paint, increases translucency and retards the drying rate to some degree. Also, acrylic flow improver helps improve the flow of paint on a base that is non-absorbent.

Matt and gloss glaze mediums are thinner than the acrylic gel. When added to water and mixed with the paint, colours become more transparent and flow more easily. This is especially useful for laying washes over large areas. These glaze mediums have a secondary function as a gloss or matt varnish, and when blended together they produce a lovely 'satin' finish.

To extend the setting time of acrylic paint, use a retarder or a water spray. The retarder is available in jars or tubes and when mixed with paint it helps it stay moist. It is useful when working in a warm dry atmosphere when the paint can harden too rapidly and also when you wish to work into wet paint.

Also available are two types of varnish to protect your finished picture – a gloss and a matt.

Other materials, such as masking fluid, which are used to create special textured effects, are shown in the section on Textures, (see page 93). By experimenting with all these aids, you will discover which, if any, will help you with your work.

In addition to all these materials you will need clean containers for water, a sketchbook and pencils for any preliminary sketch work, an eraser, and soft, clean cotton rags or kitchen roll for mopping up.

From top to bottom: sable brush, hog-hair brushes, acrylic tubes and mixing palette.

Care of materials

Commentary by Gordon Davies

It is necessary to take special care of acrylic paints and brushes if waste is to be avoided. Acrylic paints are rather harsh on brushes and these should be washed frequently while working, for it is very difficult to remove paint from brushes once it has hardened. A watercolour palette filled with water, and with two or three pieces of absorbent tissue in the bottom, provides a useful way of cleaning brushes. The brushes can be rolled against the tissue without fear of damage, and the water can be used to clean off the paint. They can

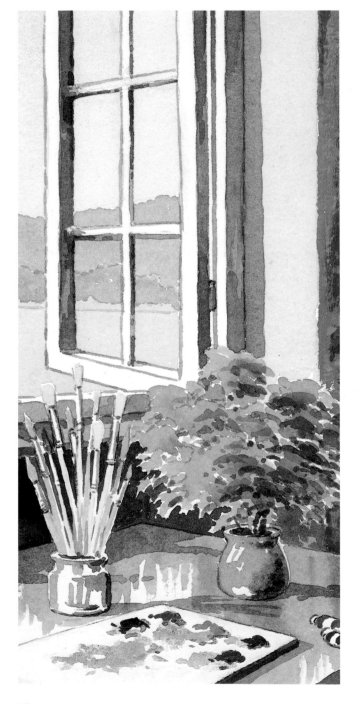

also be cleaned in water, then gently lathered in the palm of the hand with mild soap to remove all hidden traces of paint. Rinse them well with plenty of warm water and allow them to dry upright in a jar.

If the paint has hardened, soak the brushes first in methylated spirits for several hours if necessary, then wash in soapy water.

Due to the speed with which acrylics harden it is essential to replace caps on tubes and to ensure that they are tightened properly to prevent air from coming into contact with the paint. Do not allow paint to harden around the nozzle of the tube or inside the cap, as this can cause the cap not to fit properly. Soft plastic push-on caps can be bought from most art suppliers.

The best way to clean your mixing palettes is by soaking them in boiling water. To prevent waste when painting, a small amount of paint should be put on the palette and replenished frequently while you work.

Acrylics used with other painting media

Commentary by Gordon Davies

In the past it was standard practice for painters to commence an oil painting in tempera in order to establish the design and drawing. Acrylic paints can be used in this way for, with their quickness to dry, they are particularly suitable for underpainting and drawing preparatory to painting in oils. But although oil paints can be used on top of acrylic paints, the reverse is not possible. Acrylics should never be used either on top of oil paints or on to an oil-based ground. The natural antipathy of oil and water causes the acrylic paint layer to separate from the oil surface beneath.

When a heavily impastoed effect is required, it is an advantage to use acrylic paints and then work over them with oil paints if desired. There are certain qualities in oil paints which are particularly enjoyable and by using them in conjunction with acrylics it is possible to obtain the best out of both media. The quick-drying properties of acrylics are self-evident; but paints that set more slowly can have great advantages too. For instance, many portrait painters like the paint to remain workable for longer than is possible with acrylics.

Acrylic paints are an ideal medium for creating collage, when many different sorts of materials and surfaces can be combined into the painting. Their powerful adhesive qualities and the fact that they can be painted directly on to many types of unprimed surfaces make them particularly appropriate.

Acrylics can also be used in conjunction with watercolours; but remember, be careful not to allow the acrylics to contaminate the watercolour blocks, or the paint will dry out on their surfaces and make them unusable. Watercolour washes can be laid over acrylics and vice versa, and acrylic white is excellent for making small corrections to a watercolour.

Corner of an artist's studio by Ray Campbell Smith.

Colour

Commentary by Ray Campbell Smith

In writing about art materials the advantages of using a limited palette are mentioned, for harmony of colour and unity of composition are both served by using a small number of tubes. As our painting experience grows, we usually find we can dispense with certain colours on which we had previously relied, and can mix the subtlest shades from our 'basics'. In this we are following the example of Rembrandt.

Choice of colour is a personal matter and most artists evolve a range which suits their particular style and needs. In doing so they add an individual quality which makes their work easy to identify. A limited range can be used for landscape work. Still life is another matter; painting flowers, and to a lesser extent fruit, calls for a wider palette which will enable you to mix vibrant reds, oranges, yellows, pinks and purples. Some brightly coloured man-made objects, such as children's toys, may also require stronger and brighter colours than one's basic palette and so additions have to be made.

The fact that acrylic paints darken on drying poses problems for artists accustomed to watercolours, which do the reverse, and it takes some getting used to. Unless allowance is made for this, however, paintings will end up looking uniformly dingy. On the contrary, you should strive to give your work liveliness and punch by emphasizing contrast in both tone and colour. There is an advantage in placing lights against darks, but you can also strengthen the colours you want to emphasize by placing complementary colours against them. Complementary colours are opposites – red and green, blue and yellow for example. You can make a colour glow by surrounding it with a darker shade of its complementary.

Black is a dead colour; by avoiding it and using deep mixes of other colours, shadows can be painted that are deep yet vibrant with life. It is possible to obtain deep tones for example by mixing ultramarine blue and burnt sienna. Always look for reflected light in your shadows, for they add a glow and a richness to dark areas. One side of a sunny street may be in deep shadow, but the light reflected from the sunny side will add immensely to its interest. The same applies to the shadows in a still life arrangement and you should always be alert to recognize reflected colour as, for instance, when the warm glow of an orange modifies the colour of the pale cloth on which it is standing.

Above all, look for hues other than the obvious and expected ones. This analytical approach has to be cultivated and conventions put on one side. To young children, tree foliage is uniformly green and tree trunks are chocolate brown and this is how they paint them. Artists will see yellows, oranges and browns in foliage and their painting will reflect this to give variety, richness and, indeed, truth to their work.

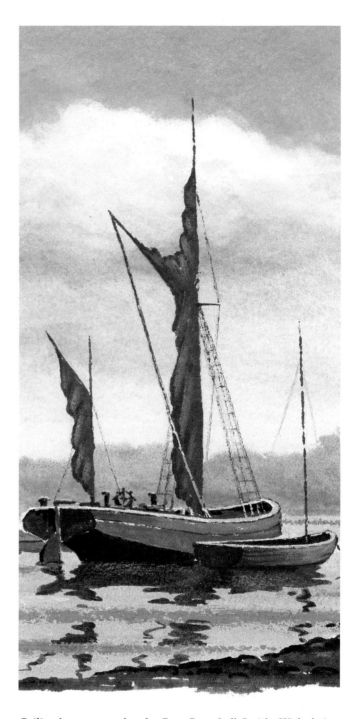

Sailing barge at anchor by Ray Campbell Smith. With their solid, beamy hulls and the rich red-browns of their sails, these sailing barges are splendid subjects for the artist (see page 51).

Techniques – surfaces and brushwork

Surfaces and application

Commentary by Gordon Davies

Already mentioned in the 'Materials' section is the fact that acrylic paints can be used on a variety of surfaces, (see page 8). Canvas, card, paper, hardboard, wood panels and plywood are all suitable surfaces that do not require priming. However, if desired, two or three coats of acrylic primer can be applied to a surface before painting commences. Let each coat dry thoroughly before applying the next.

The two illustrations on this page show some of the different effects that can be achieved with acrylics on a canvas primed with acrylic primer and on a good hand-made paper similarly primed.

Left panel

Top left: a mixture of phthalocyanine green and white is overlaid with a transparent glaze of yellow ochre with a scumble of ochre mixed with white. (A glaze is a thin, transparent wash of paint which is laid over other colours to tone them down or bring them forward.)
Top right: an area of phthalocyanine green used as a transparent wash has been similarly overlaid with transparent ochre and with a scumble of ochre and white.
Centre left: light red has been cross-hatched and overlaid with a matching wash.
Centre right: transparent and opaque greens have been washed over a light reddish brown. This sandy red ground is particularly useful when painting landscapes.

Notice how the brown wash shows up the grain of the paper.
Bottom left and right: these show how different the finished effect is when successive glazes of yellow, red and blue are used as washes and hatched one over the other.

Right panel

This illustration shows thicker paint used on a canvas ground. The canvas having a greater bite makes it easier to use the paint more thickly and with a pronounced impasto.
Top left: a solid layer of ultramarine blue has had a scumble of ochre and white applied over it and below.
Top right: impastoed white paint has had a wash of yellow laid over it.
Centre left: a transparent wash of ultramarine blue has had a scumble of ochre and white applied over it, as above.
Centre right: a broken impasto of ochre and white has had a glaze of ultramarine blue washed over it.
Bottom left: acra red has been applied thickly so as to obliterate the effect of the white canvas ground.
Bottom right: acra red has been used mixed with acrylic gel medium to achieve a heavy translucent impasto.

In all these examples the colours have been used in their pure form, or mixed with a little white to emphasize the various effects that can be obtained when using acrylic paint. Because of its quick-drying properties these effects can be achieved very rapidly. The heavily impastoed red paint sets hard within two hours whereas oil paint takes many days to dry if used in this manner. With acrylic paint it is possible to apply a glaze over solid paint in a short time without fear of the first coat picking up and mixing with the glaze.

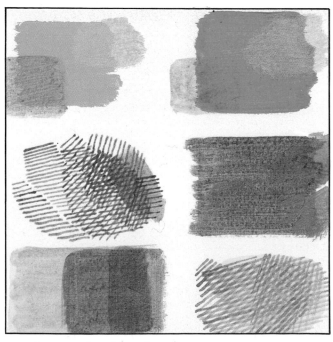

acrylics on primed hand-made paper

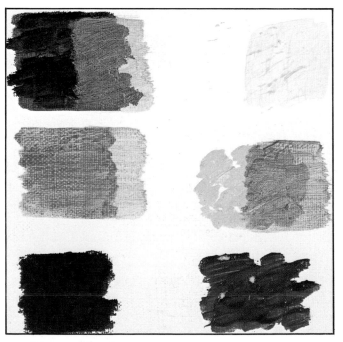

acrylics on primed canvas

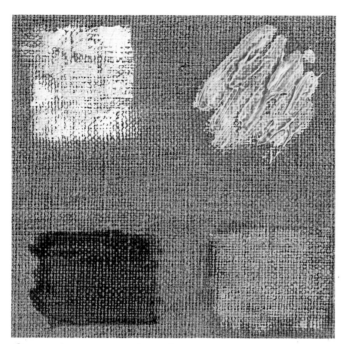

Open weave canvas ground

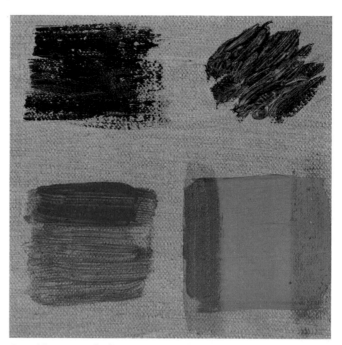

Double-primed closer woven canvas

Primed and tinted de Wint paper

Tinted watercolour paper

The four illustrations on this page show the effects of acrylics on various supports. Some of the grounds have been tinted to show up their varied textures.

Top left: this is a fairly open weave canvas which is coarse enough for the grain to show through the wash blue and on which dragged paint shows up well. On the top right a heavy white impasto is illustrated with a transparent wash on top.

Top right: here is a much closer weave which has been double primed so that the grain has almost disappeared. It is more difficult to drag paint on to a smooth ground like this and washes will tend to look more streaky. On the right I have overlaid an opaque pink with some glazes. Above burnt umber has been washed over with thin white paint.

Bottom left: this de Wint paper, primed and tinted, shows its natural colour in the warm grey strip at the bottom of the sample. The cadmium red on the left is thickly painted at the top and mixed with an equal amount of glaze medium just below. At the top the green is shown solidly painted and applied as a thin wash. In the centre the dragged white paint has been partially overlaid with a yellow glaze. To the right is a mixture of white and glaze medium.

Bottom right: this is a tinted watercolour paper. Note the effect of glazing ultramarine blue over the ground at the top left, and the green wash over the pale yellow paint, bottom right.

Basic brushwork

Commentary and paintings by Wendy Jelbert

Acrylic paints have enormous potential if used to their fullest extent. If you are intending to use them without first investigating their unique and versatile properties, it can only lead to disappointment. It is essential to learn the basics during the early stages of experimentation; this is all part of the artist's maturing process. Investing time in a non-disciplined way inevitably leads to many wasted hours.

Exercises are an invaluable method of achieving a visual vocabulary, which can only improve and expand with plenty of practice! Here, a few simple exercises are illustrated for you to try. As described on the previous page, you can use a variety of surfaces such as prepared acrylic board, canvas, or watercolour paper (as illustrated opposite).

You will need a range of colours – yellow ochre, cerulean blue and cadmium red are used here. You will also need ox-hair and hog-hair brushes, a palette knife, a ruling pen and masking fluid.

Top left: acrylic paints are dropped on a wetted surface. Watch how they bleed into surrounding areas. This technique can be used to create a 'misty' impression.

Top centre: one colour is graded gently from dark to light, just as with watercolours, giving the illusion of sky or a stretch of water. Applied more vigorously in the same way, acrylics will give a 'bubbly' highly textured wash.

Top right: two colours are graded into one another. This technique can be used to create a sunset effect, or sea and sky merging in the distance.

Centre left: spots and lines of masking fluid are applied to the paper and allowed to dry thoroughly before applying a wash. When dry, briskly rub the masking fluid off using the side of your thumb. This technique is useful as the white paper can be used to create small details on large areas of wash – sailing vessels on the sea for example.

Centre: to achieve this heavy translucent impasto, acrylic gel is mixed with yellow ochre and applied with a palette knife. Alternatively, without the gel, paint can be used straight from the tube to achieve a thick textured surface.

Centre right: experiment with a few 'runny' acrylic colours by blending them together on the paper. The resulting almost accidental impressions can be used to create lovely effects such as diffused images, distance or a foggy scene.

Bottom left: yellow ochre is overlaid with a scumble of blue. Letting one colour peep out from another allows the painting surface to 'sing' with patterns of colour. Many artists in the past have placed burnt sienna under a landscape.

Bottom centre: to give a surface an exciting textural impression short, stabbing lines, dots and streaks can be used.

Bottom right: you will make better progress if you exploit the full potential of your brushes. You only need a few brushes for each painting and you will be surprised how versatile they can become. Try using the tips and the sides and experiment by rolling them upwards and sideways.

This detail is taken from the finished painting 'Poppyfield' on page 97. The paint is used thickly like oils to create a textured effect.

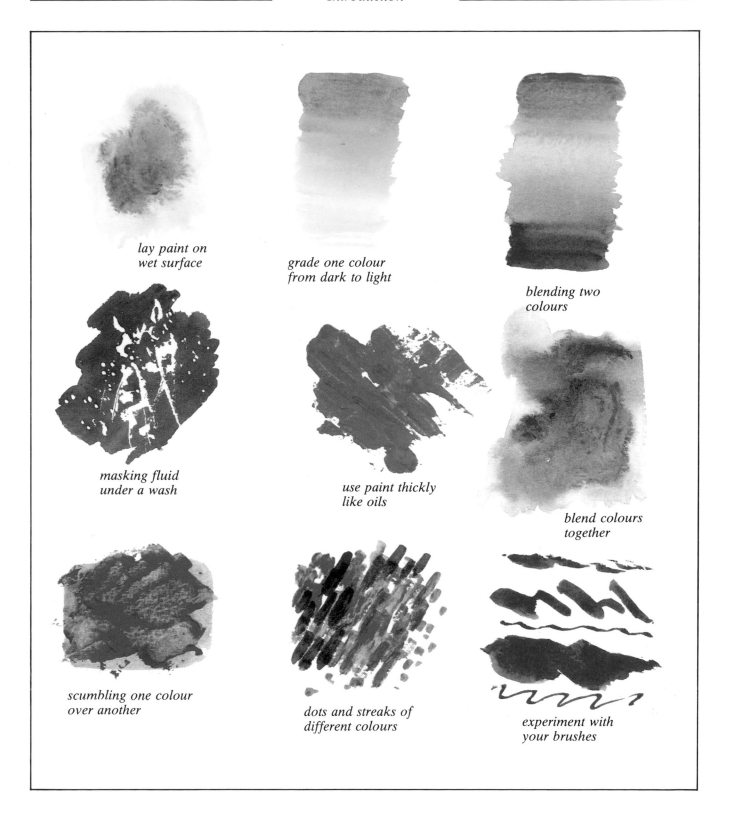

*lay paint on
wet surface*

*grade one colour
from dark to light*

*blending two
colours*

*masking fluid
under a wash*

*use paint thickly
like oils*

*blend colours
together*

*scumbling one colour
over another*

*dots and streaks of
different colours*

*experiment with
your brushes*

Draughtsmanship and composition

Commentary by Ray Campbell Smith

Draughtsmanship

However good the painting technique, a finished work is only as good as the underlying drawing. This is why we should do all we can to improve our draughtsmanship at every opportunity. Of course, subjects differ widely in the demands they make upon drawing skills and a simple landscape of fields and trees will present far fewer problems than, for example, a group of figures against a complex background. But weak drawing, even of simple subjects, is difficult to hide and any painter who wishes to raise his or her standards should make a firm commitment to improving skill with the pencil.

One way to do this is to have a sketchbook always at hand and to use it to record quick impressions of any and every subject that catches our eye. The majority of these sketches will probably never be developed, but the very act of making them gradually improves our technique and makes us more alert to the visual opportunities around us.

Recognizing a good subject is a skill that needs nurturing. Some people find that the use of a 'viewfinder' (see below and page 18) helps them to spot a promising subject. This aid is nothing more than a piece of stiff card with a rectangular aperture, about the size of a postcard, cut in the middle. It is surprising how

this simple device can help to isolate good compositions from a complex scene and, moreover, relate the lines of the chosen subject to the lines which form the margin of the paper or canvas.

Composition

One of the problems facing the artist is that of finding a satisfactory composition. It is not a difficult matter to find subjects that are attractive in themselves, but the artist needs more than this – he needs a subject in which there is balance and harmony. The problem can usually be overcome by careful reconnaissance which aims to find a vantage point from which the elements of the scene or subject matter will arrange themselves in a balanced manner. Occasionally, however, one comes across a scene which refuses to respond to this treatment: all the artist can do is to make the best of it or, in his imagination, vary the arrangement of what he sees before him to improve its composition – a ploy that does not meet with universal approval. Composition in landscape is covered in a little more detail in the section on landscapes, see page 19. Composition in still life can be found on pages 58 and 59. Cyril Turner discusses his method of composition for miniature paintings on page 110.

Pencil sketch by Wendy Clouse.

Perspective

Commentary and drawings by Ray Campbell Smith

The basic rules of perspective are shown on this page, but more information is given, where appropriate, in the, chapter on landscapes, see page 24, and the chapter on waterscapes, see page 40.

Perspective is a subject which causes a great deal of needless difficulty. Once the comparatively simple rules are mastered, the problem ceases to be a problem!

These rules are based on the self-evident proposition that the further away an object is, the smaller it will appear, and when it is on the true horizon, it will virtually disappear. This is shown diagrammatically in Figure 1, below.

This diagram can be adapted to show how to construct the lines of a solid figure, such as the rectangular building shown in Figure 2. Notice that the lines above eye-level slope down to the vanishing point, while those below eye-level slope up to it, which, of course, accords with our observation. Notice too, that the true horizon is synonymous with eye-level and is often, in practice, obscured by hills or other nearer features. Only the sea horizon, or the horizon of a dead level plain, will coincide with the true horizon.

The nearer an object is, the steeper will be the perspective slope. Another point to note is that the position of the vanishing points will vary with the angle of the object, which Figure 3, showing a curving linc of houses, makes clear.

It is, of course, possible to use these methods to construct your objects, but it is probably better to use them to check what you have drawn against perspective error.

Earthenware vessels and china vases, frequently seen in still-life groups, can cause the inexperienced artist difficulty. Figure 4 indicates (a) how symmetry may be obtained by the use of vertical and horizontal construction lines and (b) how the common fault of a torpedo-shaped ellipse may be avoided.

To draw a symmetrical vase like the one shown in (a) first construct a vertical line and then a series of lines, having equal length on either side of it and at right angles to it. The extremities of these lines, when joined, will give you the right and left-hand profiles of the vase. When drawing an ellipse as in (b), remember that it is simply a foreshortened circle and, although the curves at the right and left-hand extremities of a shallow ellipse will be very tight, they will not be sharp points.

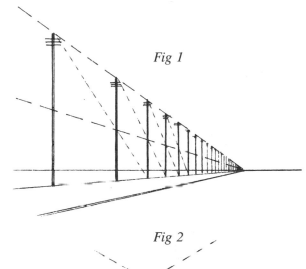

Fig 1

Fig 2

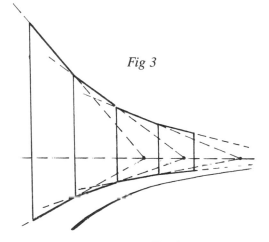

Fig 3

Fig 4

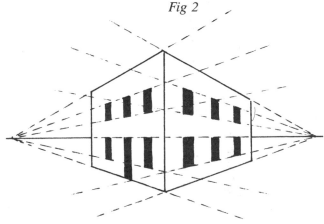

(a)

vertical and horizontal construction lines

(b)

✗

✓

ellipse

Landscapes BY WENDY CLOUSE AND GORDON DAVIES

Introduction

Commentary and paintings by Wendy Clouse

Acrylics are an ideal medium for the landscape painter because they allow the freedom to paint in many techniques. They can be used like gouache or in the traditional oil techniques (using water, of course, in place of turpentine). Acrylics can also be used as a watercolour medium in either the traditional technique, or wet-in-wet.

To me there are few occasions as enjoyable or exciting as a warm sunny day in the English countryside, when I can set up my easel, paint to my heart's content, and be at peace with the world. This does not happen very often, unfortunately. Not only do we have the weather to contend with, but flies, mosquitoes, curious people, cows, not to mention traffic. Another problem is the amount of equipment or clothes one needs for a day's painting. I have frequently seen people set out on a landscape painting trip so laden that they were lucky to get as far as their front gate.

My suggestion is to take a small rucksack/backpack. Into this, put only the tubes of colour you need for the day – eight should be enough. The colours I suggest are burnt sienna, yellow ochre, cadmium red, alizarin crimson, lemon yellow, ultramarine blue, Prussian blue and sap green. Pack them loosely – wooden boxes just add extra weight. Take no more than three brushes, two or three soft rags, and squash bottles. These, in the normal or small size, are ideal for carrying water and also, cut in half, make ideal light water pots. You will need two of these pots, one pencil, and one rubber. It is a good idea to take two small canvasses or boards as you may wish to begin a second painting while the first is drying, or are enjoying yourself so much that, having finished the first painting, you decide to stay and start another. Make sure, however, that your boards or canvas or paper are no larger than your rucksack. It is much easier to carry all you need in one bag.

You will also, of course, need a small palette, I suggest one of the disposable kind. If you also take along a small plastic bag, at the end of the day's painting you can tear off the disposable used palette sheet and pop it into your bag to take home and throw away. For that matter, even during the day you may want a clean palette. In addition, a few sheets of sketch paper or a small sketch pad will be of great use.

Besides your art materials it is usually sensible to take along an extra sweater, a plastic raincoat (these can be purchased in a tiny bag), insect repellant, and suntan lotion. Sandwiches and a flask of coffee are pleasant, some would say vital, extras. All of these items well packed will fit into quite a small backpack.

When everything is packed, a light canvas stool should just fit over the top before you close the bag. The flap will then hold it in place.

All that you have left to carry now is an easel – a wooden or metal portable one is best – and you can buy shoulder bags too put those in. Even with your backpack in place and easel under or over your arm, distance should be no problem and you will still be able to open (and close) gates or climb over stiles.

There is nothing more terrifying to the beginner-painter than going out into the countryside to paint for the first time. Everywhere one looks there are scenes just waiting to be painted; but everything also seems so vast compared to one's little canvas, and there are so many interesting subjects available that it is difficult to decide what to paint.

My suggestion is to make a small viewfinder, similar to the one shown on page 16, to act as a frame. Hold the viewfinder in front of your eyes, look through it, and scan the area until you light upon a subject or area that interests you. Next, still looking through the viewfinder, bring it first closer, then push it further

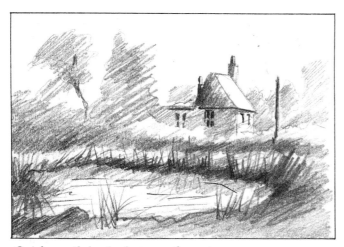

Quick pencil sketch of a tranquil country scene.

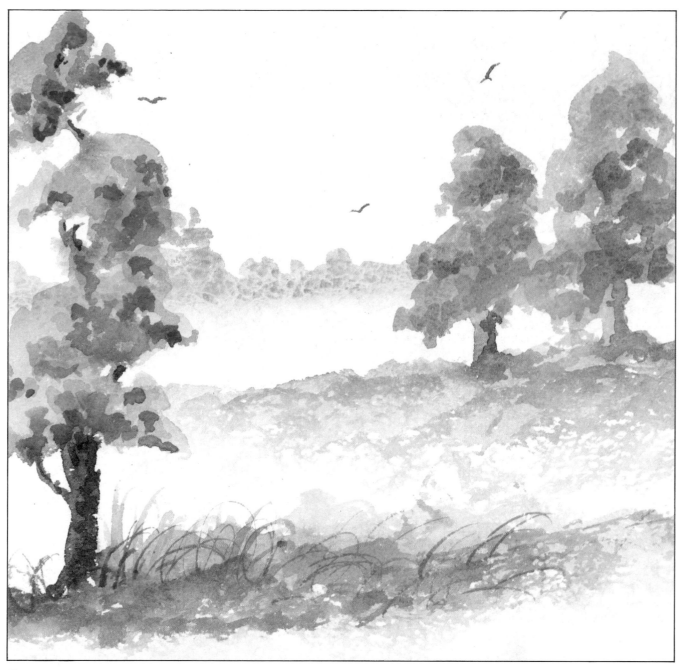

Trees are the most prevalent objects in a landscape, but they are the most difficult to draw and paint. Carry a sketchbook with you whenever you are outdoors and spend time studying their textures and shapes, (see page 20).

away from you (to act like a telescopic lens on a camera) until you can decide how best to frame or compose your painting, and whether you want your subject, for example, close up or in the distance.

Remember, however, if you are not very experienced, to begin with simple subjects which demand few colours, for example a stile, a tree, a country lane or a fence in the hedge. Simple subjects such as these can, I assure you, make delightful paintings.

When you have selected a subject it is a good idea to make a few thumbnail sketches, approximately 10 cm

by 7.5 cm or 4 in by 3 in. This way, by the time you begin the actual painting, you will know your subject well, and feel at ease with it. This preparation will also help to eliminate too much rubbing out and beginning again.

Always, by the way, keep a sketchbook with you so that when there is no time to paint, you can make a quick sketch. Used in the studio on a rainy day, with a little creativity, these sketches can be turned into paintings, often much larger than you would attempt in the open air.

Trees

Trees tend to be the most prevalent objects in landscape paintings, but they are also the most difficult to draw and paint. It is seldom indeed that we see a landscape painting without some trees or bushes – even the desert has scrub bushes and low gnarled trees. It is very important, therefore, for the landscape painter to gain as much experience as possible in drawing and painting trees. Carry a sketchbook with you, so that whenever you are in the country, or having your lunch break outdoors or in the park, you can spend a few minutes studying the texture of the trunk, the bole (the area where all the main branches leave the trunk) or

the shape of the tree as a whole. These studies will prove to be invaluable later when you are completing a landscape painting.

Study the trees in the distance; see how they seem as I mention on page 24, to be of one value, or one flat colour. This is especially noticeable on a misty morning when the distant landscape appears in flat layers, each closer layer being slightly darker than the previous one, and all not very different from the colour of the sky.

Trees in the middle distance will be more detailed, branches possibly showing and foliage appearing in two values (light and dark) instead of a single one as in distant trees.

The time spent studying trees proves to be of greatest value, of course, when painting them into the foreground of a picture; for here all the painting of trunks, branches and foliage is at its strongest both in detail and in colour, (See also pages 22 and 23).

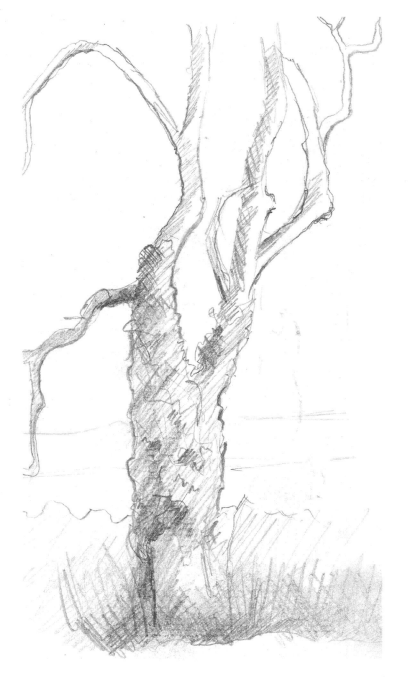

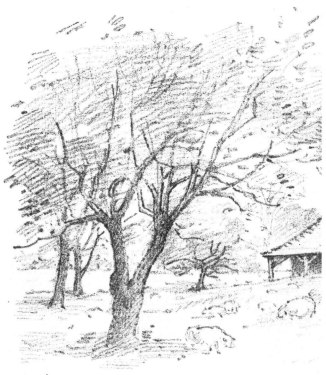

Above: a pencil sketch by Gordon Davies.
Left: *A sketchbook study by Wendy Clouse.*

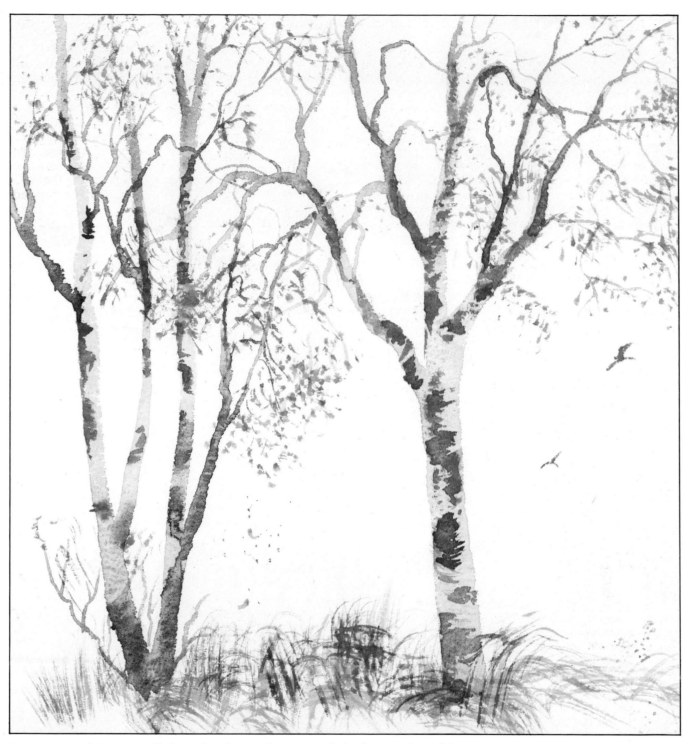

Time spent studying trees will always be of great advantage to the landscape painter. It is important, however, to see the tree as a round mass and not flat.

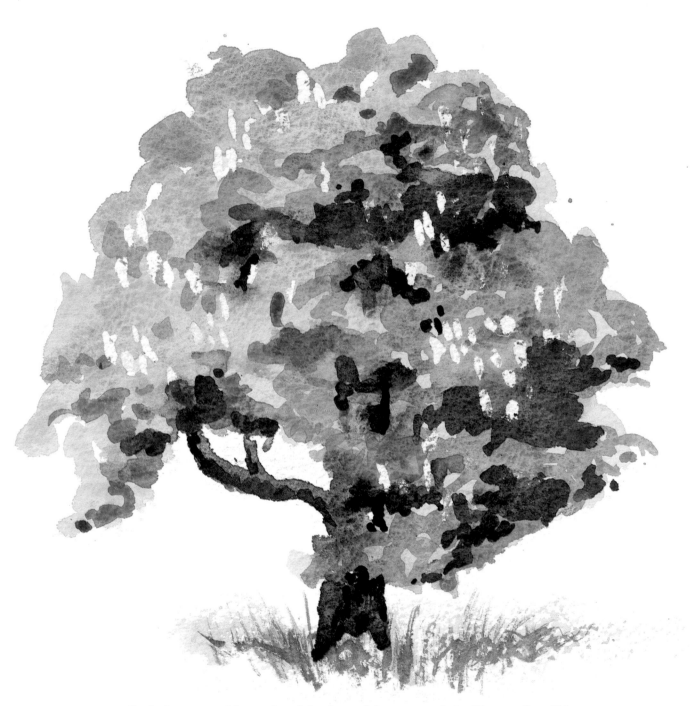

Study the texture of the trunk and the shape of the tree as a whole. These studies will be invaluable later when you are completing a landscape painting.

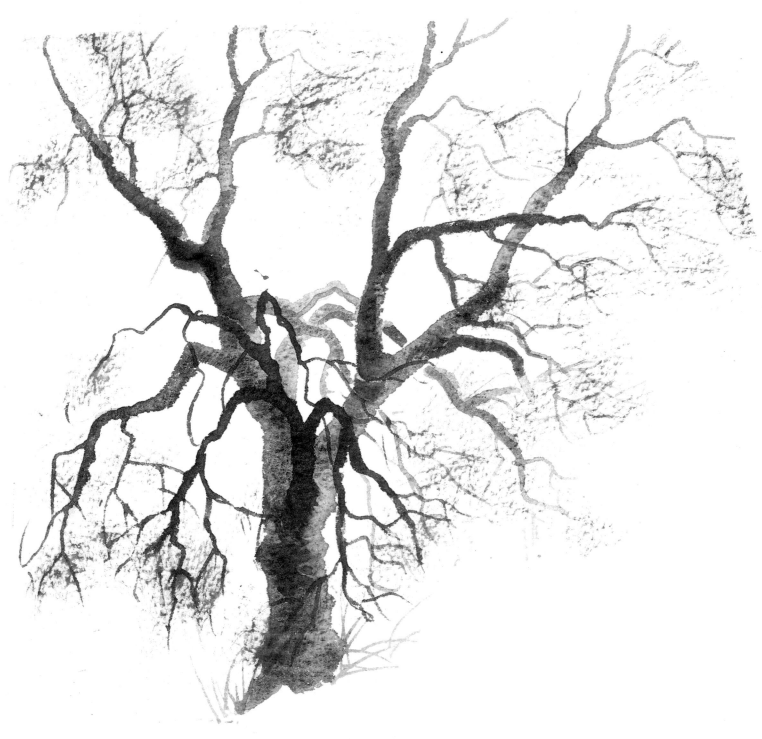

Branches extend not only to the sides, they extend 'back-away' and also protrude towards the viewer. This requires some thought as the foreshortened branches are not easy to draw.

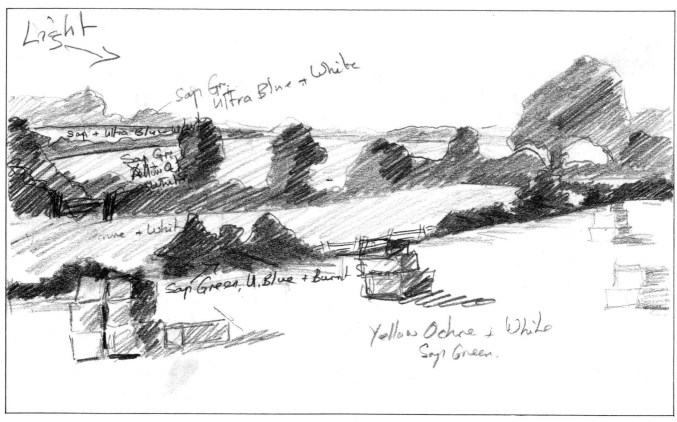

Pencil sketch of 'Summer fields' shown opposite.

Perspective in landscape painting

The word perspective can be a frightening concept to someone who is still learning to paint; and some students at first find perspective a total mystery. In landscape painting, however, perspective is less of a problem than it is, for instance, in drawing buildings. There is less need to worry about linear perspective, rather the need is to concentrate on *aerial* perspective – receding colours and tonal values which create the illusion of space and depth.

The atmosphere through which we view the landscape is filled with particles of dust and water vapour. These will seem to cast a blue-grey veil over distant objects, and even over not-so-distant objects. As a result they dull the colour and also reduce surface detail. Colour changes, therefore, as much as lines and shapes do. Accordingly distant hills, mountains, and trees will appear to become lighter the farther away they are; and very bright colours will look lighter and hazier in the distance.

I have painted in 'Summer fields' opposite a simple landscape with trees in order to demonstrate the effects of aerial perspective. In the distance the trees are small, en masse, a flat cool grey in colour, and with no detail.

In the middle ground I have added a little green to the grey colour and have painted the trees and bushes

in two values, light and dark – not a bright light or a strong dark, however, as I will need these tones for the trees in the foreground. Here I have painted in full colour and used three values – light, middle tone and dark. By using aerial perspective I have created an illusion of depth and space on my paper or canvas.

When painting landscape, of course, it is vital to consider the weather. It is of no use to paint the sky grey to portray a cloudy wet day and then to paint the rest of the picture in bright colours as if it were a sunny day! On a grey day all the colours must be toned down or made greyer. On a sunny day all colours will appear to be lighter and brighter.

Summer fields

Size: 37.5 cm × 26.5 cm (15 in × 10½ in)
Paper: fine grain oil-painting paper
Brushes: nos. 8, 4 hog-hair oil
Colours: yellow ochre, white, burnt sienna, ultramarine blue, sap green, and a small amount of cadmium red in the foreground glaze

This painting demonstrates the effects of light on the landscape. To me it portrays a typical English landscape on a hot summer day, the sun intermittently shining and with heavy haze in the distance. It also demonstrates, as I have described, aerial perspective.

24

First I give the canvas a covering of yellow ochre. When this is dry I make my sketch (see opposite), block in all the colours, and then begin to paint more thickly and in more detail. I paint the sky first, followed by background, middle ground and, last foreground.

As I complete the painting I find that, because the background is too strong, it does not give enough depth to the picture. So I mix a small amount of ultramarine blue with a little white, water it right down and use this as a glaze to veil and therefore to lighten my background. (A glaze is a thin, transparent wash of paint which is laid over other colours to tone them down or bring them forward.)

Finally, to bring the foreground forward, I make a very watery mixture of lemon yellow and cadmium red (orange) and lay a transparent glaze over the foreground to brighten it.

'Summer fields' aims to demonstrate both the effect of light on the landscape and aerial perspective.

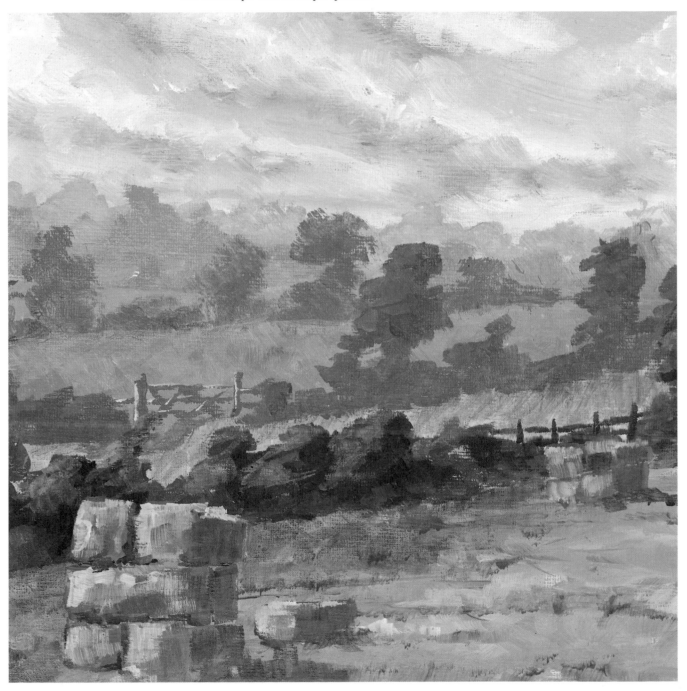

Stage 1

Stage 2

Stage 3

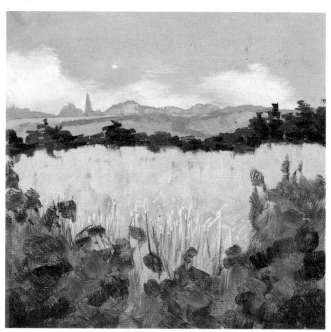

Stage 4

Over the hedge: demonstration

Size: 26.5 cm sq (10½ in sq)
Paper: fine grain oil-painting paper
Brushes: nos. 8, 4 oil brushes (hog-hair or nylon bristle); no. 1 rigger
Colours: burnt sienna, ultramarine blue, sap green, yellow ochre, lemon yellow, and titanium white

This painting opposite is composed in a style similar to the techniques used by oil painters. It demonstrates flat, distant background in contrast with very detailed foreground.

Stage 1

I first give the canvas a wash of burnt sienna – this is using the colour mixed quite thinly with water. Painting your support with burnt sienna before you begin a landscape gives the picture a warm earthy glow.

After the wash is dry I place my horizon line and paint the sky, for which I use ultramarine blue, burnt sienna, and white. When the white clouds are dry I mix a little yellow ochre with white and apply it to one side of the clouds – the sunny side. Even clouds have a light and dark side.

26

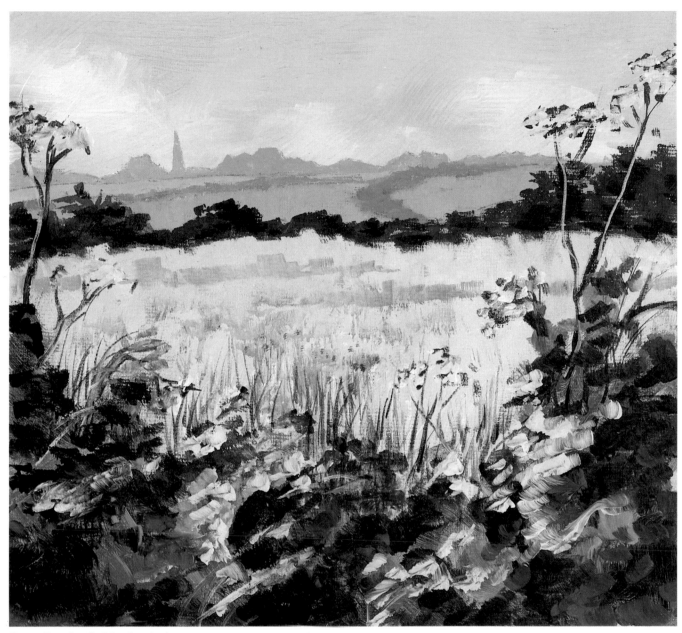

Stage 5 – the finished painting

Stage 2

The distant church and trees I paint with a mixture of sap green and ultramarine blue, with white. The whole of the distant background is painted in a deliberately flat style. Distance, as I pointed out under 'Perspective' (see page 24), cuts down on brilliance of colour and detail. The fields and hedges are painted with the same three colours, although I add slightly more sap green.

Stage 3

I now paint in the middle ground hedge and cornfields; first the hedge, dark, with a mixture of sap green, ultramarine blue and burnt sienna. I than add a little white to this mixture to add a second, light value (two values for the middle ground, a little more detail than in the distance).

The cornfield is painted with a mixture of yellow ochre and white. A few detail strokes are added in the front with the no. 1 rigger, using ultramarine blue and burnt sienna.

Stage 4

Here I add very vigorous brush strokes to the foreground with mixtures of sap green, burnt sienna, ultramarine blue and yellow ochre.

Stage 5 – the finished painting

To complete the painting I add finer detail to the foreground, introducing white mixed with the colours from the previous stage. I also add more detail to the cornfield, but make sure not to put in too much light detail along the bottom edge of the painting or in the corners because this could drag the viewer's eye away from the real focus of the painting.

Using photographs on cold rainy days

Used properly, photographs can be a useful adjunct to the painter, (see also pages 88, 94 and 104). Personally I like to make my sketch from a photograph and then put the photograph away, otherwise I find myself tied to minute detail and untrue colours. It is better to be creative, in my opinion, and to decide for myself what colours I want to use. For example, a winter scene may be painted from a summer photograph and vice versa.

Painting from photographs is not as enjoyable as painting on the spot unless, of course, it is pouring with rain or freezing cold with a gale blowing. At these times, if you have the urge to paint landscape, it is less hazardous to do so in a warm and comfortable studio.

I try always to carry a small camera with me. One never knows when a paintable subject may appear, but so often it occurs when time is too limited to paint or even sketch. It is also handy to have a camera to record different angles and aspects of a subject to keep on file for future reference.

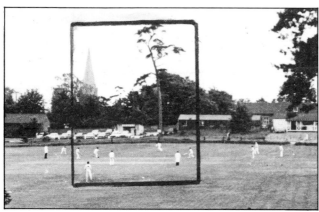

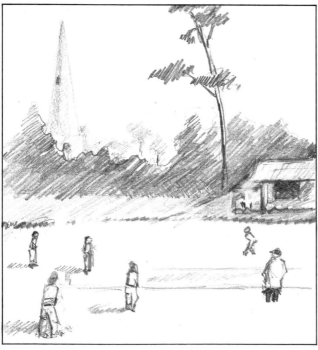

Bridge over the Grand Union

Size: 26.5 cm sq (10½ in sq)
Paper: fine grained painting paper
Brushes: nos. 8, 4 hog-hair oil

This painting I developed in the studio from the rather poor photograph shown here. A poor photograph is often, I think, an advantage because one is less tempted to copy the colours of the photograph. Ideally black and white photographs are better, for they force one to be creative with colour.

For the greens in the picture I use mixtures of sap green, ultramarine blue, burnt sienna and white. The

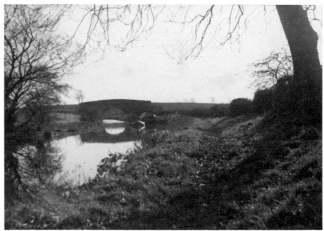

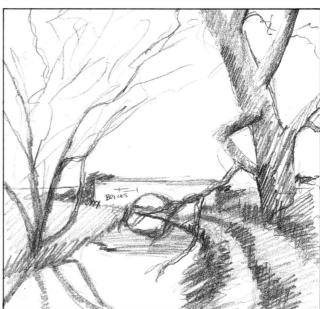

Above: *photograph and sketch for the painting opposite.*

Left: *when working from photographs you can develop just a small detail into a complete picture. Here I have outlined part of a photograph which I hope to develop and which is actually the focal point of the whole picture. First, I work out the composition in a rough sketch.*

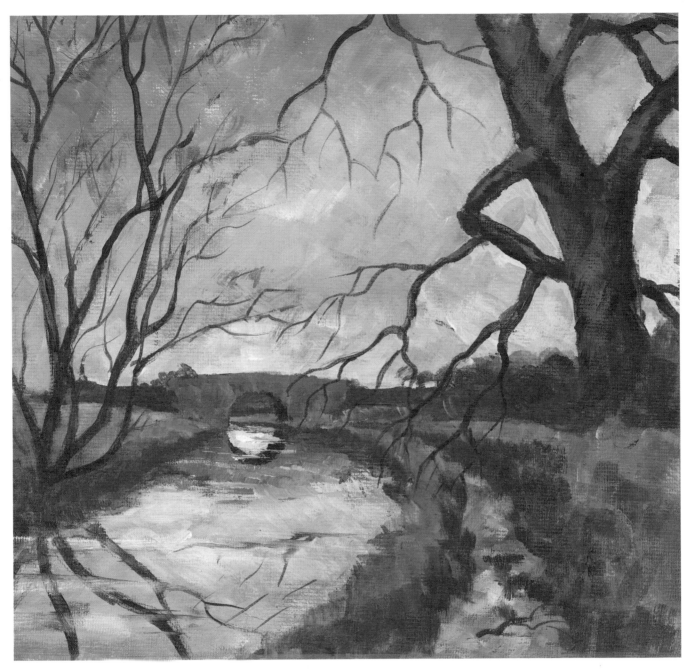

trees are painted with burnt sienna, ultramarine blue, raw sienna, and white. The bridge and its reflection I paint with cadmium red, yellow ochre, and white. When the paint dries I add a tiny amount of sap green to give the impression of moss.

To begin with, I make the sketch from the photograph opposite, and in the process somewhat change the format. I then put the photograph away.

This bridge was built over the Grand Union Canal between North Kilworth and Welford on the Northamptonshire/Leicestershire border. The sole purpose was to connect fields on opposite sides of the canal for the passing of animals and farm traffic.

Before I put the drawing on to the canvas I prime it with yellow ochre and white to give the whole painting a glow, and to help convey the feeling of a sunny November afternoon.

After the wash is dry I apply the drawing and paint the sky with ultramarine blue, burnt sienna and white at the top, grading down to yellow ochre and white, while in places a little cadmium red is introduced, mixed with white to a pink colour. When I finish the sky I continue with the background, working from the farthest distance forward to the foreground.

When a painting contains water – a lake, river or canal – I always leave that element until last. I find that I then judge the values better and obtain the right contrast with the rest of the picture, (See also the chapter on 'Waterscapes' on pages on pages 38–57.)

I find it very exciting to paint a landscape in the studio away from the actual scene. It gives me a freedom which I do not quite possess on the spot since I can see the detail so much more clearly when I am sitting only a few yards from my subject.

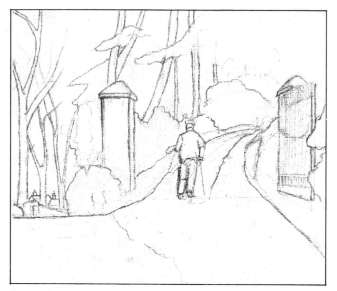

Stage 1

Stage 2

The gardener: demonstration

Size: 26.5 cm sq (10½ in sq)
Paper: fine grain oil-painting paper
Brushes: nos. 8 and 4 hog-hair oil (or nylon acrylic); no. 1 rigger
Colours: ultramarine blue, burnt sienna, cadmium red, sap green, raw sienna, lemon yellow and titanium white

This painting demonstrates the individual characteristics and advantages of acrylics in building up a painting, in the use of glazes, and also in the addition of a figure to a landscape.

Stage 1

This sketch was made from two different sources. The gateway, roads and surroundings were drawn when I was on holiday in Devon in a little place at the mouth of the Dart river. The figure of the gardener was taken from photographs that I had taken of a locally well-known character in my native village in Leicestershire. The two subjects thus brought together form an interesting study.

Stage 2

I first make a tracing of the whole sketch but transfer to the canvas only the main elements, the sky and the ground. I then fix a line with a thin mixture of burnt sienna and water. Next the sky colour is blocked in and completely painted.

Stage 3

I return the traced sketch to the canvas, transfer the background trees and houses, and paint them in.

Stage 4

Once again I overlay the tracing and add the gateway, the drive and the bushes to the painting. I make sure that the strongest colours and values (lights and darks) are kept for the foreground. Background colours and value will, of course, be softer with less contrast to create the illusion of distance.

Stage 5 – the finished painting

I now trace the figure and add it to the painting, trying, as I do so, to keep the colours of the clothing in harmony with the rest of the painting. A figure or object painted in bright or totally different colours will appear to be floating in front of the rest of the painting instead of being part of the whole.

Because of the speed at which acrylic dries it is possible to build up a painting, as I have this one, in the space of a few hours. Another asset lies in the application of glazes, for these too can be added within a short period of time.

In this painting I have provided a glaze of ultramarine blue by washing over the whole background, sky, trees, and distant buildings to create a sense of greater distance. Blue, being a cool colour, causes the parts of the painting glazed with it to appear to recede. Orange, being the complementary colour to blue, is used as a glaze over the foreground to bring that forward.

Glazes can, of course, be used in any part of a painting to tone down, brighten or enrich, and they are very often applied over an opaque area.

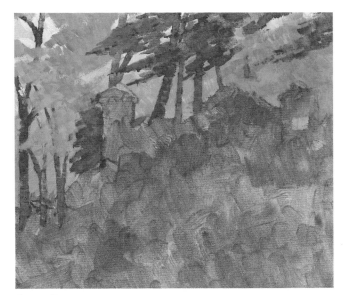

Stage 3

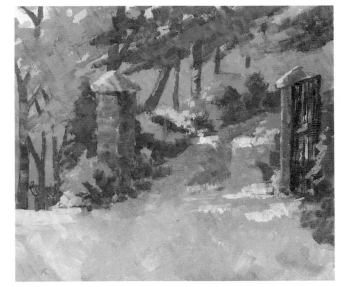

Stage 4

Stage 5 – the finished painting

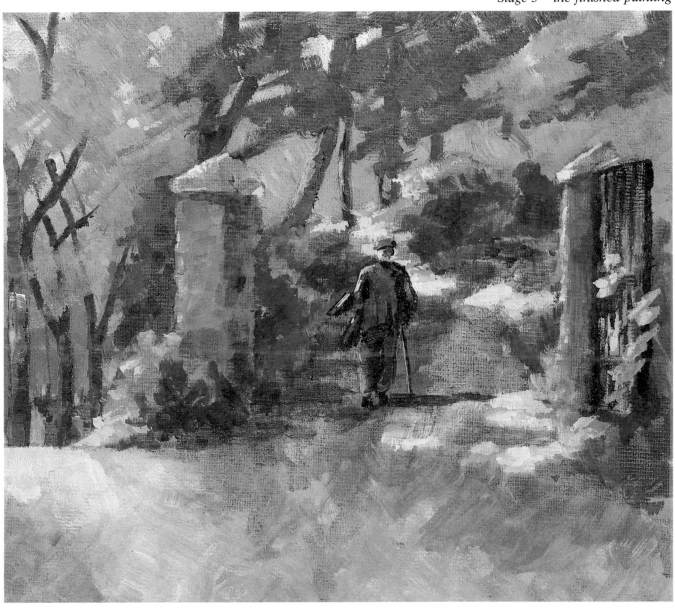

Stage 1

Stage 2

Stage 3

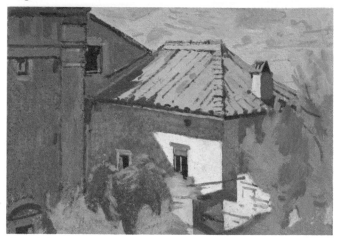

Stage 4

Santa Marie Nuova, Cortona: demonstration

Commentary and paintings by Gordon Davies

When painting landscape I use my painting box (see opposite, below) and carry a light aluminium chair because when one has to walk any distance it is important to reduce the weight of equipment. I also think it is a mistake for the novice to carry too many colours in his painting box.

For me the following colours are essential; cobalt blue, Mars yellow, cadmium yellow, burnt sienna, burnt umber, viridian green and of course, white. I also like to have by me: ultramarine blue, cadmium red, cadmium orange, Indian red, Hooker's green, cerulean blue and olive green pale. See how far you can get using about half a dozen colours and add more colours as and when you need them.

I do not paint large paintings – more than 45 cm × 60 cm (18 in × 24 in) – outside the studio, and for these I use either plywood panels primed with acrylic primer, or good quality rag paper primed and tinted a pale warm sand colour. They are then mounted on to plywood afterwards for framing.

This small painting illustrates a simple approach to painting a landscape in acrylics because it contains in essence many of the problems to be encountered in painting any landscapes.

The subject may be divided into three parts: the bushes in the foreground, the building, and the hill beyond. The perspective is elementary, the eye level being in line with the top of the sunlit roof. The painting was made in the early afternoon with the sun in the south-west. I mention this for it is important, when you see a good subject, to note the time of day. So much depends on the position of the sun, for returning later at a different time can cause difficulties and disappointment. Also when you are painting in strong sunlight it is not often possible to work for more than two hours, for in that time the sun will have moved a considerable distance across the sky.

Stage 1

I like a warm sandy red ground for painting landscape and was here working on a rough paper, primed and tinted with raw umber and burnt sienna. To start, I draw out the main design of the subject with a sable brush using a mixture of cobalt and Mars red. At this

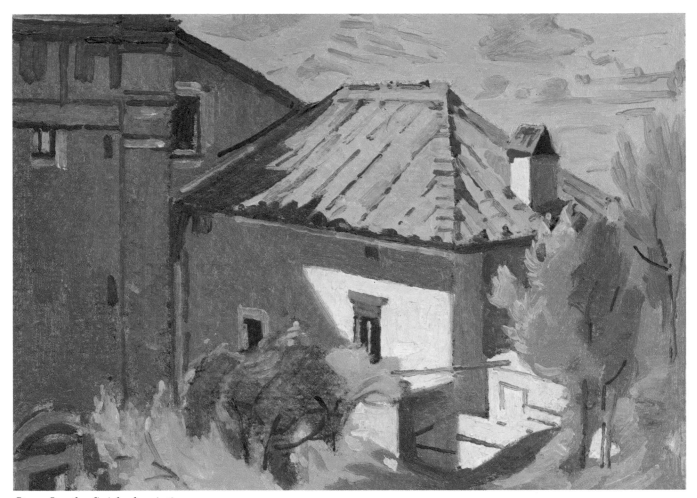

Stage 5 – the finished painting

stage I ensure that the proportions and perspective are correct.

Stage 2

I continue with the drawing and wash in the large areas of shadow still using cobalt and Mars red. The shadows will change continually, so it is necessary to work rapidly at this stage. I paint in the areas of the building in full sun.

Stage 3

Having painted those parts of the building in full sun a clearer idea of the design begins to emerge. The distant hills appear cool by comparison with the warmer greens of the trees in the foreground; these are painted thinly with the warm sandy ground showing through. The sunlit roof of terracotta tiles appears mostly of an almost lavender colour.

Stage 4

I next draw the dark accents in the building and paint into the shadows, keeping these cool in relation to the sunlit walls. I also add in some of the detail in the distant hills, keeping the colour close in tone. I draw the tiling on the roof, adding small touches of pink, and paint in the green blind over the window.

Stage 5 – the finished painting

To complete the painting I continue drawing into the building, and I add touches of a lighter green to the foreground trees.

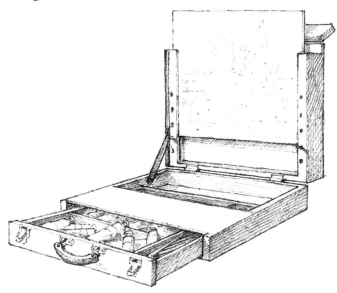

Painting box: *I devised this box myself. The painting panel is adjustable vertically and the drawer for paints and brushes opens to allow me to paint at a greater distance than is usual with a painting box on the lap. For greater stability a jointed support is fixed to the back of the box.*

Stage 1

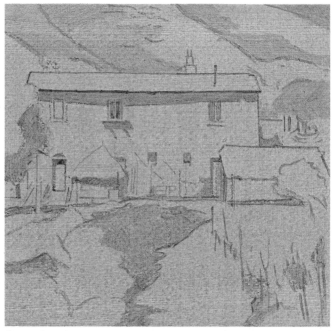

Stage 2

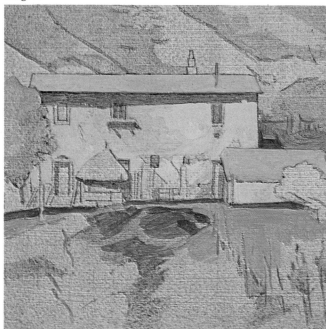

Stage 3

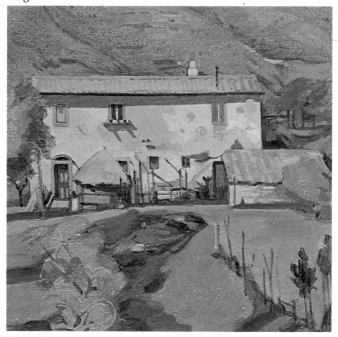

Stage 4

Farmhouse at Cortona: demonstration

For materials and paints used, see page 32

Stage 1

In this painting of a Tuscan farmhouse care had to be taken to get the proportions of the building and the spacing of the windows exactly right. Notice the shallow pitch of the roof and the distance between the ground and first-floor windows. In a land of brilliant sunshine the windows are small. The ground floor is reserved for the animals and stores, and the living quarters are above, on the first floor.

Stage 2

Once I have established the proportions of the building and indicated the lie of the land I next draw in the main areas of shadow using a mixture of cobalt and burnt umber. In those areas of green in shadow I prefer first to put down a warm brown to underlie the dark green. The shadows are cool in tone on the building and on the distant hills.

34

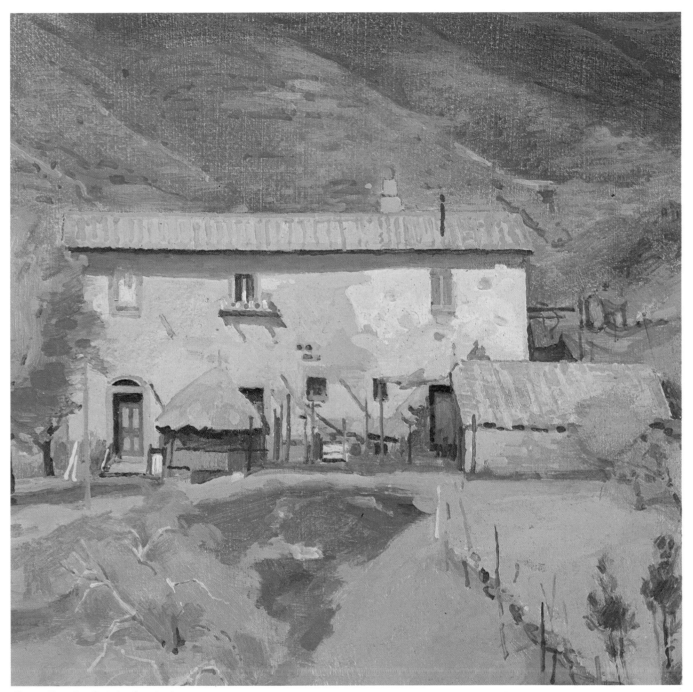

Stage 5 – the finished painting

Stage 3

At this point I put out more colours: cadmium yellow, cadmium orange, ultramarine blue, Indian red, Mars yellow and viridian green. I like to keep the dark green thin and transparent and let the warm ground colour show through as this gives a special quality to the green. When painting the farmhouse I was fascinated by the variety of colour to be found on the wall and liked especially the pale blue from the wash that had been sprayed to protect the vine growing over the door on the right.

Stage 4

Now I have covered the ground the painting is looking rather more complete. Purplish blue gives distance to the hills and contrasts well with the cool green of the grass and the grey-blue of the olive trees. Some of the dark accents are modified with a thin wash of colour to lighten them slightly. It is possible to make these adjustments very easily with acrylic paint because of its drying speed.

Stage 5 – the finished painting

Some adjustments to the tone of the dark green of the centre foreground and some more drawing into the distant hill and olive-trees completes this study. Notice how keeping the paint thin on the distant hill, and allowing the ground colour to break through, helps to suggest distance and atmosphere.

Stage 1

Stage 2

Stage 3

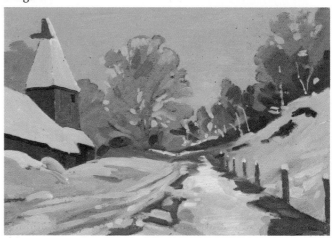
Stage 4

Oast house and lane in winter: demonstration

For materials used, see page 32.

Although Kent has often been termed 'the garden of England', in winter when it snows it does so with a vengeance! The high ground where I live catches the northern and easterly blasts, the snowflakes sometimes so heavy we are marooned for days at a time. Kent, too, has its own local architecture; oast houses for drying the hops that flavour our beer are scattered about the countryside providing the district with its unique features. Just such a prospect greeted me last year, and, although it was bitterly cold, I decided to make a quick study of a local oast house at sunset with the trees festooned with snow.

When you are painting out of doors in the winter, and especially when the ground is frozen, a useful tip is to take a piece of wooden board on which to stand. One can feel warm so long as one's feet are not cold or wet.

A subject such as this needs to be painted with urgency, for not only will the chill make it difficult to

work for long, but a rapid thaw can transform the subject in a most unwelcome manner! It is therefore best to work with a limited palette and here I use cobalt blue, cadmium orange, burnt umber, cadmium yellow and white.

Stage 1

Using a warm tinted ground I first sketch in the main lines in cobalt blue to establish the design.

Stage 2

I like to paint the sky early on in the painting as this helps to clarify the design of the whole picture. Here the sky is a rather greenish blue, changing to a pale clear orange pink at the horizon. The trees against the sky are thick with snow which appears as a greenish grey against the pink of the sky. Some areas of snow are painted in.

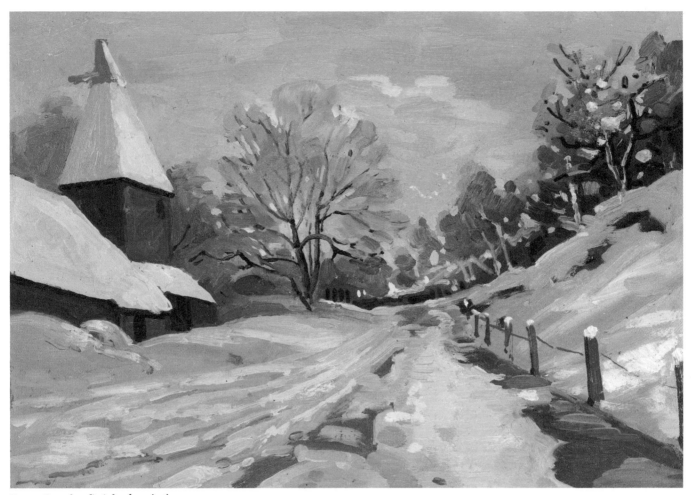

Stage 5 – the finished painting

Pencil sketch of an oast house.

Stage 3

The shadows on the snow are very cool in tone, in fact the most clearly blue areas of colour in the painting, in contrast to those areas in full light which reflect the warm tints of the sky. These are the next parts to be painted as I work all over the surface of the painting. The dark areas of colour under the trees and in the puddles are useful in the design and help to establish the brilliance of the snow.

Stage 4

I begin to pull together the detail in the picture, searching out with a small sable the trunks of the trees and the linear rhythms of the tracks in the snow. I also break up the tree forms in the centre of the picture where the sunset shows through.

Stage 5 – the finished painting

The lightest areas of tone on the snow and in the sky I leave to last, after having painted in the darkest accents on the tree trunks and the building. Notice that there is very little pure white in this picture and that the colour in the snow is reflected from the sky.

Waterscapes BY RAY CAMPBELL SMITH

Introduction

In this chapter I shall be dealing with water in its natural forms – seas, lakes, rivers, streams, ponds, waterfalls, rapids, puddles, even wet roads. I shall cover both still water and moving water, and will examine how this colourless liquid can borrow colour from its surroundings. It is a difficult but rewarding subject, and one that has attracted artists throughout the ages. To quote but one example, Turner's fascination with water is apparent in many of his finest works.

One occasionally sees paintings which have for their subjects just sea and sky, and very compelling they can be in the hands of a master. However I am more concerned with water as part of the landscape, including its natural surroundings – the banks of inland water and the shores of sea and ocean.

Water not only forms an integral part of the natural world, but its presence adds an extra dimension to the landscape. It can impart a sparkle to an otherwise drab scene as, for example, when a shining river meanders across the dun-coloured saltings to the sea. The very flatness of still water can be an aid to composition, contrasting as it does with the vertical forms of adjacent features such as buildings and trees.

Technique

As with oil painting, I first give my support a dilute overall wash of some warm colour suitable for the subject, often a mixture of raw or burnt sienna. This kills the rather inhibiting white of canvas or paper and, if allowed to show through later work, helps to unify the painting and hold it together. I then block in the larger areas of light and shade. When working in the open it is advisable to establish the shadows early on and then stick to them whatever the sun may do in the meantime. The shaded areas should be deeper in tone than the shadows they represent, to allow for the subsequent addition of lighter-toned paint to create texture – as in oils, working from dark to light. I sometimes find it helpful to use full washes of paint for large smooth areas such as a sky or sheets of water, as these contrast well with the rougher, broken applications of paint to adjacent areas.

It is good practice to stick to a limited palette as this tends to give one's work a unity which the employment of a wide range of colours can easily destroy. It also makes it easier to get to know the individual properties of the chosen tubes more thoroughly, though this aspect is perhaps less important than it is with watercolour where the handling characteristics of different colours can differ considerably.

Finally, it pays to work quickly and boldly, not only to avoid the problem of premature drying, but because it can impart looseness and spontaneity to one's work – this in the comforting knowledge that mistakes can be readily rectified without loss of freshness.

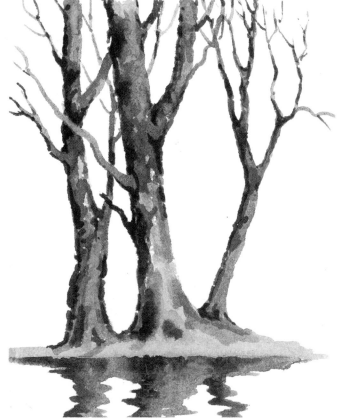

Tree group reflections

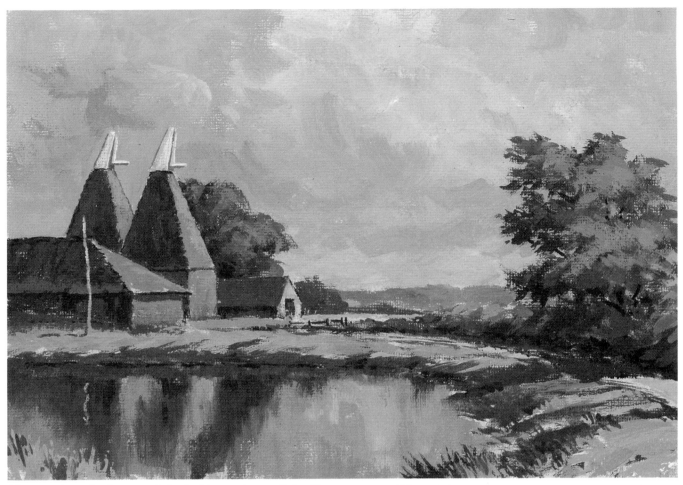

This painting of a farm pond, bathed in evening sunlight, illustrates some of the points made on this page. The surface of the water is ruffled by the breeze just sufficiently to break up the mirror image, although the reflections of the main features are still recognisable.

There are a number of places where lights are placed against darks in order to enhance tonal contrast and give the painting more form and interest. Notice also how the line of the middle-distance hedge leads the eye towards the group of farm buildings.

Still water

Perfectly still expanses of water give rise to perfect mirror images. While these have an undoubted appeal of their own, for the painter this attraction has its dangers. Unless the scene depicted is a very simple one, the mass of inverted detail in the reflection can make for an over-elaborate and over-busy foreground. However, a gentle breeze, blowing across the surface of the water, breaks up these reflections and creates a softer effect which does not compete with the detail above it. This softer treatment of reflections is certainly a simpler matter than attempting mirror images which present tricky problems of perspective to the inexperienced artist. But even with these more diffuse reflections it is important to ensure there is harmony between them and the scene above. This may seem self-evident, but it is surprising how many paintings contain reflections which have little in common with the subject-matter above them.

The next step is to analyse the tones of the objects reflected, bearing in mind that light objects have rather darker reflections and dark objects somewhat lighter ones. The colour of the reflections will be modified to some extent by the local colour of the water, and this effect will be the greater the more directly one is looking down into the water.

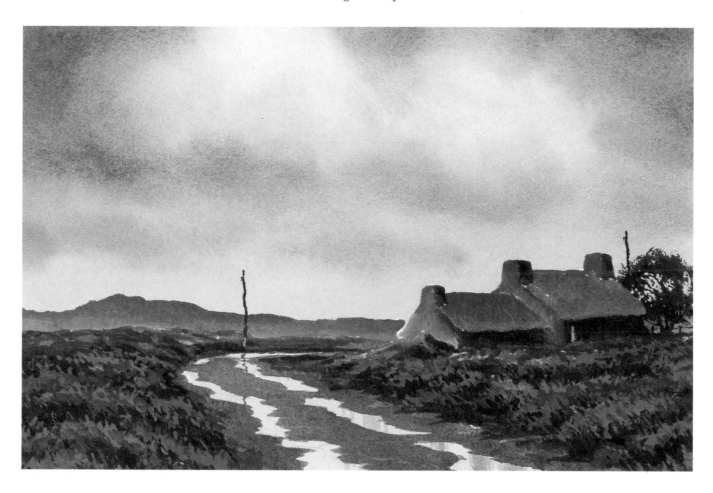

Reflections and perspective in still water

Although the diffused reflections discussed on page 39 do not necessitate an exact application of the rules of perspective, it is still necessary for the artist to understand the theoretical construction involved in order to avoid errors. If he knows where the mirror image would fall, he is unlikely to offend the laws of perspective too flagrantly when going for softer effects.

To decide how much of an object standing a little way from the water's edge will be reflected, a simple construction is necessary. First, imagine that the horizontal plane of the surface of the water cuts right through the bank to a point vertically below the object in question. This is shown in Figure 1 opposite above, which demonstrates how much of the church steeple will be reflected. Figure 2 shows a similar construction in the case of a river bridge. In both cases the vertical arrows above and below the horizontal axis line (AA) are of equal length.

If the water in a lake or a river fails to lie flat, it will be due to faulty perspective in the drawing of the banks. Another common fault is that of making the line of a distant margin vary too much in a vertical plane. The distant shoreline of a large lake will appear almost as a straight line, unless one is looking down on the scene from well above water level. At such a distance flat areas are very much foreshortened and however

indented the far shoreline, any deviation from a horizontal straight line will be very slight. By virtue of this foreshortening even a sizeable field will appear as a narrow strip.

A sudden breeze, blowing across the surface of an expanse of water, will produce an area of lighter colour which breaks up the smooth reflections around it. This can occur whenever an errant breeze happens to blow and the resultant colour is lighter because wind-ruffled water reflects much more of the sky above. This phenomenon can be put to good use if, for example, we wish to interpose a band of paler colour between land and water for compositional reasons, as in the painting of the lake on page 43. This horizontal stretch of light colour can serve the additional purpose of helping the surface of the water to 'lie flat'.

In dealing with the problem of reflections in still water, we must not forget such shining surfaces as wet roads and pavements. Dry metalled roads are not a very appealing subject for the painter but wet tarmacadam is another matter and offers attractive and interesting possibilities in the reflections. These will be modified to some extent by unevennesses in the surface, or by tyre marks, or gutters, but we must include them, otherwise our wet roads will look somewhat too Venetian!

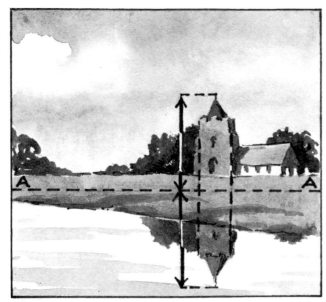

Fig 1

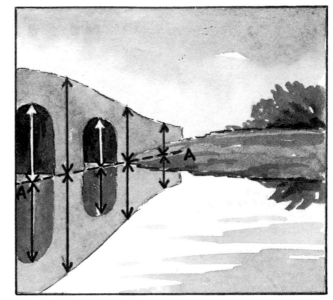

Fig 2

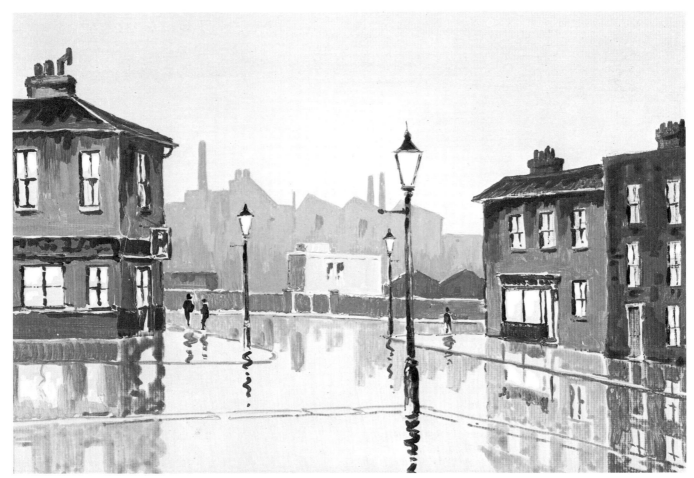

Above: *wet roads and pavements offer attractive and interesting possibilities in the reflections.*

Opposite: *there is not much water in this painting of an isolated moorland farmhouse, but the puddles in the ruts play the vital role of linking the luminous sky to the dark landscape and help to heighten the dramatic contrast.*

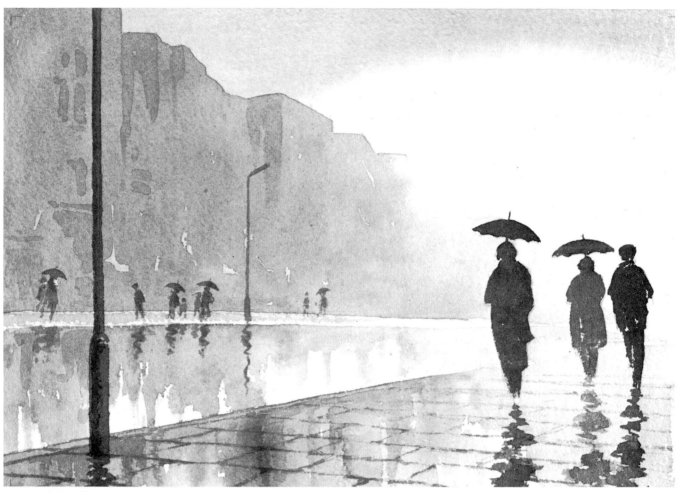

Mist and drizzle create an atmosphere of mystery in a city street.

Atmosphere

The landscape artist aspires to more than the mere mechanical recording of the outdoor scene and seeks to breathe life and feeling into his subject-matter. He is therefore more concerned with feeling than with accurate detail.

The murky and misty weather conditions which soften outlines and clothe the landscape in mystery require us to be imaginative in recording our impressions of the scene. In this way, we encourage those who view our work to use their own imaginations.

The paintings on these two pages both attempt to capture the effects of mist and drizzle on a city scene.

The background in the painting above is largely obscured by the mist and only the vaguest forms of the buildings are suggested. I have emphasized the radiance created in the misty air by the luminous patch of sky on the right of the painting, and have indicated how the reflected light emphasizes the feeling of wetness on road and pavement. The treatment of the figures, little more than grey silhouettes, reinforces the overall atmosphere of mystery.

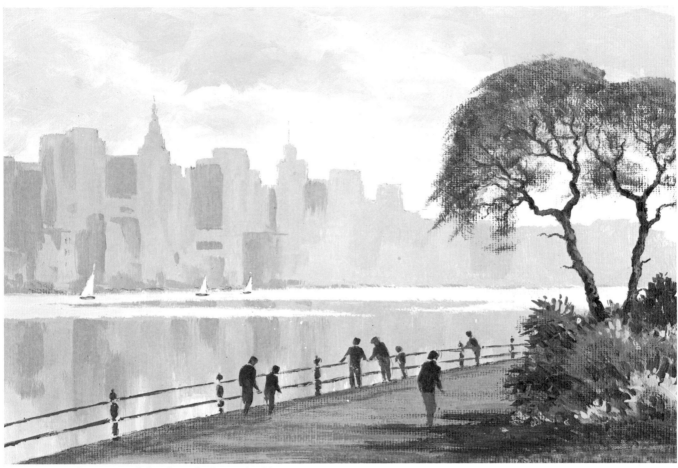

A mist rising from a city lake shrouds distant buildings.

Lakeside city

Here the effect of the misty conditions is to convert the distant buildings into a grey silhouette, paler at the base where the mist is rising from the lake. A gentle breeze has ruffled the surface of the water to create a paler stretch which provides a convenient break between the buildings and the lake. The nearer objects – the figures, the trees and the railings – have been painted deeper tones to provide contrast with the paler background and so create a strong feeling of recession.

Conditions such as these encourage me to use subtle, pearly colours instead of varying tones of grey. This greatly enhances the attractiveness of the painting.

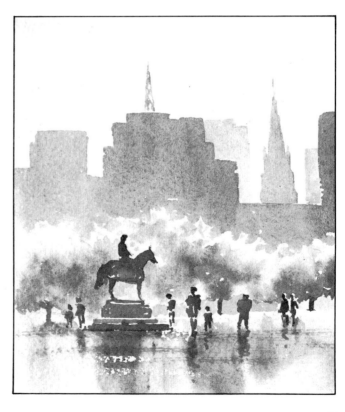

Reflections in a city centre.

Stage 1

Stage 2

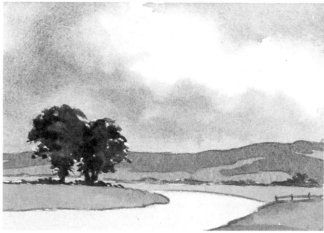

Stage 3

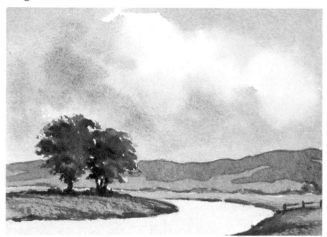

Stage 4

River painting: demonstration

Size: 23 cm × 30.5 cm (9 in × 12 in)
Paper: Arches Rough 600 gsm (300 lb)
Brushes: nos. 7, 8, 9 bristle and 6 sable
Colours: titanium white, Payne's grey, raw sienna, burnt sienna, light red, ultramarine blue, Winsor blue

Stage 1

With the sable brush and diluted Payne's grey I sketch the principal lines of the composition. Using washes of raw sienna for the sunlit clouds, ultramarine and light red for the cloud shadows, and ultramarine for the patch of blue sky – all blended with titanium white – I paint in the sky, and allow the colours to merge at the margin.

Stage 2

Using ultramarine blue, a little light red and titanium white I paint in the distant hills. I add the wooded areas with a deeper mix of the same colours. Then I paint in the middle distance fields, with a blend of titanium white, Winsor blue and raw sienna.

Stages 3–4

The nearer fields I tackle with a mixture of ultramarine, raw sienna and titanium white. Next I prepare a stiff mix of Winsor blue and raw and burnt sienna, plus a little titanium white, and paint in the trees, using the roughness of the paper to achieve a broken edge. With a slightly lighter mixture than for the trees I paint in the river banks and apply texturing to the nearer fields.

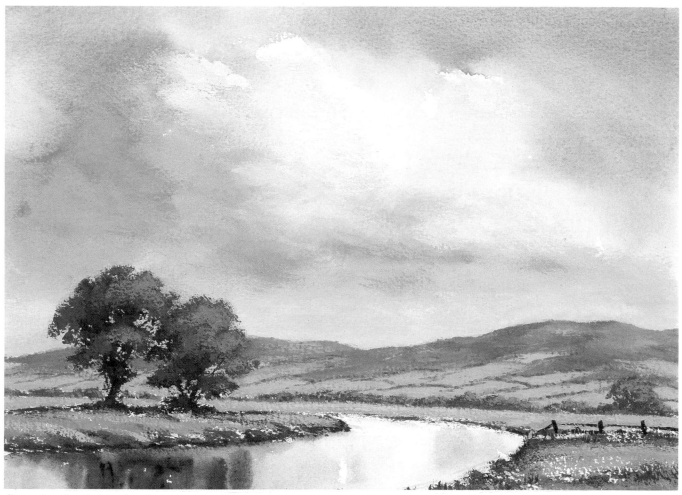

Stage 5 – the finished painting

Stage 5 – the finished painting

I prepare liquid washes similar to those used for the sky and apply them to the river area, using bold, vertical strokes. The reflections of the trees and river banks are added with a rather paler version of the mix used for the trees themselves and blending is allowed to occur.

Water in movement

Moving water represents a more difficult problem than still water, not least because the very movement makes it more difficult to study. The first stage is careful observation; the moving water must then be mentally 'frozen' at a point when its form appears most expressive. Although the subject is always on the move, the chosen instant will constantly recur, not in exactly the same form, perhaps, for no two waves, or two eddies, are identical, but closely enough for practical purposes.

The sea

When tackling seascapes, the first question is, where to place the horizon? It should not be exactly half-way up the page, so the basic decision is whether to give greater prominence to the sea or to the sky. If the sky is an interesting one, a low horizon will do it better justice. This will entail adopting a low viewpoint and so condensing the expanse of sea. There is a positive advantage in this for the foreshortening of the wave pattern will force us to concentrate on the nearer waves, to the benefit of the composition. A higher

viewpoint will take in many more waves and it is all to easy then for these to become repetitive and produce a 'corrugated iron' effect.

Another early decision to make is whether to paint looking straight out to sea or to adopt a slightly oblique angle. I generally prefer the second alternative as it avoids the danger of the composition degenerating into a series of horizontal lines. If I include a strip of sand at the edge of the sea, for example (see opposite), there may well be a tide-mark of pebbles, seaweed or other flotsam. This twists and turns with the configuration of the shore and its inclusion can help to describe the contours of the foreshore and add to the interest.

An angry sea is an impressive sight and one that poses a real challenge to the painter. Not only must he or she capture the form and shape of the waves – they must be imbued with life and movement. The artist will use plenty of white to represent foam and white horses and he will give bursts of spray a soft edge and try to place them against a dark background to provide contrast.

In the painting below the massive wave exploding

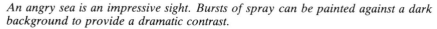

An angry sea is an impressive sight. Bursts of spray can be painted against a dark background to provide a dramatic contrast.

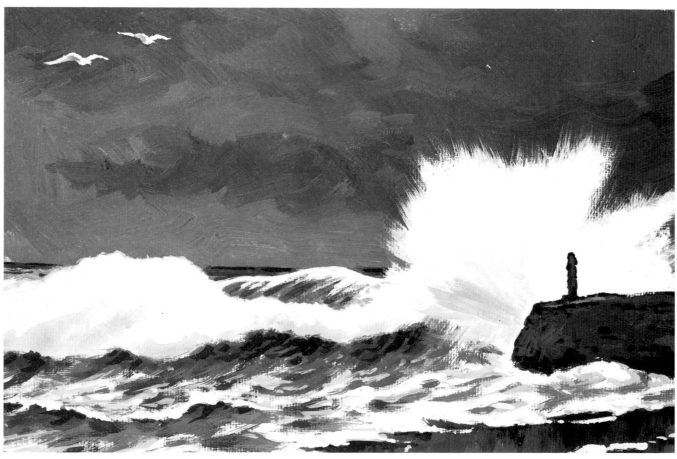

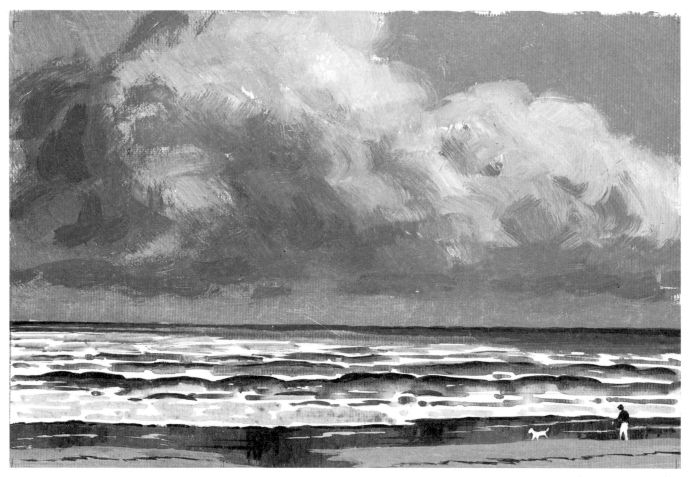

The lively, cloudy sky suggests a low horizon and more emphasis is given to the curving line of the nearest wave. The figure and dog provide interest and a crisp note; they are painted dark against light and light against dark.

against the stone groyne throws a column of white foam high in the air. Dramatic tonal contrast has been provided by placing it against a dark mass of storm cloud. The low viewpoint emphasizes the height and power of the waves and makes it a simple matter to concentrate on just one impressive wave and make a feature of it.

Violently moving water is filled with air bubbles. These have the effect of lightening its tone. In this painting the dark treatment of the groyne and the wet sand serves to highlight the pale tone of the sea. The gulls add a crisp note against the lowering sky, and, though small, help to provide compositional balance.

In studying natural water in all its forms, it is necessary to include its setting – the banks of rivers and lakes and the shorelines of seas and oceans. Here I am looking at the foreshore and deciding how best to convey its essence in paint.

On a typical sandy shore, with an ebbing tide, there are three main elements, the sea itself, a strip of wet sand which the sea has left behind, and, below that, a stretch of dry sand.

The sea may, in its turn, be divided into four elements: the dominant form of the nearest line of waves which provides a telling accent; below it the flat foamy expanse of the last spent wave; then the foreshortened area of the more distant waves which will be treated in much less detail; and, perhaps, a distant stretch of cloud shadow which may well extend to the horizon. All these are related, so they must be looked at as a whole and their tone and colour analysed.

The painting above contains all these elements. The lively, cloudy sky suggests a low horizon. The curving line of the nearest wave is strongly marked while the more distant waves are merely suggested. The strip of wet sand reflects the dark sky but its deep tone is relieved by lines of foam left by a receding wave. The stretch of dry sand is lighter in tone and this, in turn, is relieved by a dark line of seaweed, roughly parallel to the margin of the sea. The figure and the dog provide a crisp note and are painted dark against light, and light against dark.

Stage 1

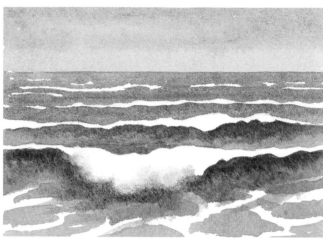

Stage 2

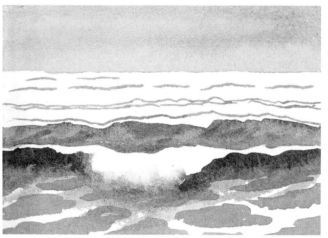

Stage 3

Stage 4

Breaking wave: demonstration

Size: 16.5 cm × 23 cm (6½ in × 9 in)
Paper: Saunders Not 600 gsm (300 lb).
Brushes: nos. 6, 8, 10 sable.
Colours: titanium white, Payne's grey, raw sienna, light red, ultramarine blue

Stage 1
With a dilute wash of Payne's grey, I sketch in the principal lines of the nearer waves and the horizon. As this subject lends itself to a liquid use of acrylics, I choose sable rather than bristle brushes, and use plenty of water. I paint the sky with a wash of raw sienna and a touch of light red and, while this is still wet, apply horizontal strokes of ultramarine and light red to suggest the clouds.

Stage 2
The near wave is painted with a mixture of raw sienna and Payne's grey; the white paper is left to stand for the foam patterns. I add Payne's grey for the shadowed area at the top of the wave and soften this with clean water to indicate spray.

Stages 3–4
Here I complete the near wave, and indicate the curling line of the second wave with Payne's grey.

Again I complete the distant area of sea with Payne's grey plus a little ultramarine; and I leave chips of white to stand for the white horses.

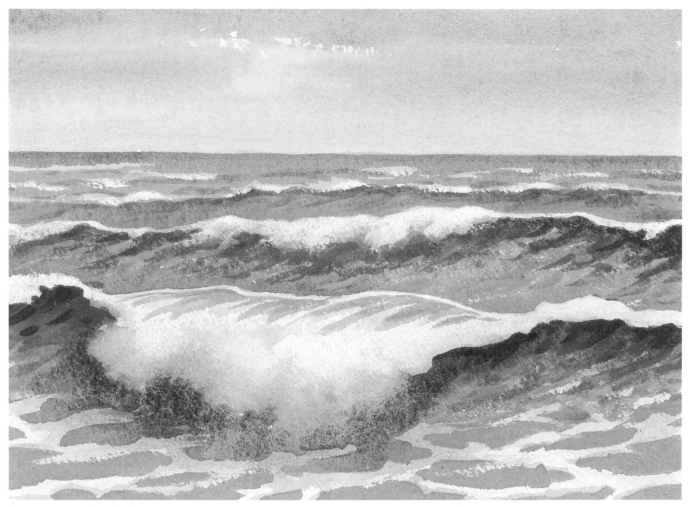

Stage 5 – the finished painting

Stage 5 – the finished painting

All that remains now is for me to add some pale shading to the areas of foam in shadow with a mixture of ultramarine, light red and titanium white.

Boats

Boats are inseparable from the coastal scene and their inclusion adds interest to any marine painting. Their masts can help to 'tie together' the mainly horizontal lines of the typical seascape. In the black and white sketch of the two beached boats opposite above, the masts span the bands of sky, sea and sand and link them together.

Except when drawn in profile boats are tricky subjects and, incorrectly drawn, can look remarkably unseaworthy. Some teachers suggest using a rectangular framework, with carefully constructed perspective, and drawing the boat shape within it, as in the sketch opposite below. While this is some check against gross error, only careful observation will reveal the subtle line of the keel and gunwale.

The beamy old wooden hulls above, winched up the shingly foreshore and standing out boldly against a stormy sky, made a subject I could not resist. Much as one admires the greyhound lines of modern racing yachts, there is something basic and honest about the solid shapes of working boats.

The sky was cloudy but lively and constantly changing. I chose a moment therefore when a lighter patch appeared immediately behind the boats, to enhance their dramatic impact. The dark clouds overhead provided a telling contrast with the light tone of the sea.

A foreshortened cloud shadow adds emphasis to these clouds and gives the expanse of water a feeling of perspective. The wet shingle by the water's edge is

comparatively dark in tone and this provides useful additional contrast.

Some painters, with orderly minds, have a way of tidying up the scene before them, but it is a temptation which should be resisted with such scenes as this, for the presence of a certain amount of clutter adds to the atmosphere and the character of the subject. After all, who ever saw a tidy boatyard?

The treatment of the shingle is fairly rough as I did not want to divert attention from the fishing boats or get bogged down with painting individual stones – a quick indication of a few is enough to suggest the remainder.

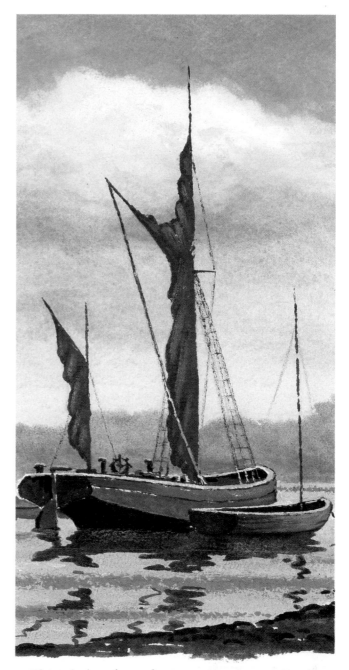

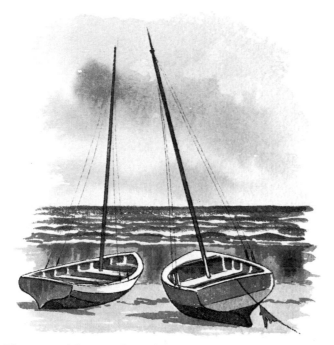

The masts of these two boats help to tie together the horizontal strips of sea and sky.

A rectangular framework can be used when drawing a boat.

The painting above shows a sailing barge at anchor. There are not many of these fine old craft left. They are no longer used as coastal bulk carriers but serve social and recreational purposes.

With their solid, beamy hulls, the rich red-browns of their sails and the bold verticals and diagonals of their masts, spars and rigging, they make slendid subjects. I painted this group on a day calm enough to produce interesting reflections and sought to emphasize the dark impact of the furled sails and masts against a bright sky, using ultramarine, light red, raw sienna, burnt sienna and, of course, titanium white.

Stage 1

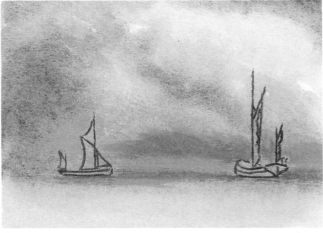

Stage 2

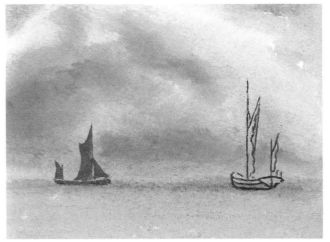

Stage 3

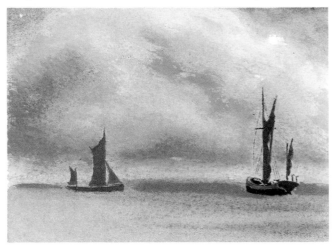

Stage 4

Sailing barges: demonstration

Size: 18 cm × 25.5 cm (7 in × 10 in)
Paper: Arches Rough 600 gsm (300 lb)
Brushes: nos. 7, 8, 9 bristle, and no. 6 sable
Colours: titanium white, Payne's grey, raw sienna, burnt sienna, light red, ultramarine blue

Stage 1

I tint the whole of the paper with a wash of raw and burnt sienna. With the sable brush and dilute Payne's grey I then sketch in the outlines of the sailing barges.

Stage 2

Mixes of raw sienna are prepared with a little light red for the sunlit clouds, ultramarine and light red for the cloud shadows, and ultramarine and Payne's grey for the blue sky – all blended with titanium white. Then I paint in the sky and the misty line of cloud shadow on the horizon.

Stages 3–4

The sea is painted with titanium white, Payne's grey and raw sienna, with a hint of warmth added here and there with light red. The more distant sailing barge is rendered very simply with light red, ultramarine and titanium white.

I put in the suggestion of soft wave shadows on the sea and paint in, a little more crisply, the moored barge, adding detail with the tip of the sable brush.

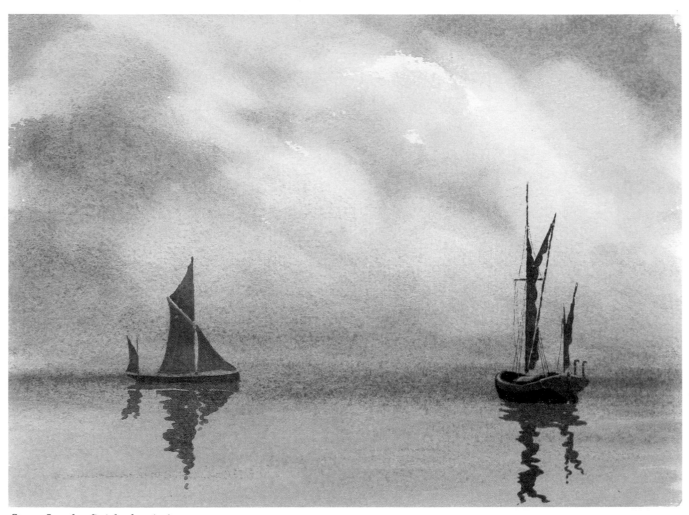

Stage 5 – the finished painting

Stage 5 – the finished painting
All that remains now is to paint in the reflections against the luminous evening sky which shades into the limpid water below.

Movement in fresh water

Still expanses of water give rise to mirror images, whereas breezes and currents can break up reflections, forming interesting patterns and effects.

Lakes and streams

In the painting of the mountain lake (below), movement is confined to the area of wind-ruffled water below the far bank, and to the nearer ripples caused by the small beck entering on the right. Wind-ruffled water reflects, of course, the sky overhead rather than what lies beyond, and it is always lighter in tone than smooth water. Here it is shown as a narrow, horizontal strip of white. The ripples caused by the entry of the little mountain stream have been simplified and put in boldly. Both these modifications to the smooth surface assist the perspective of the tarn and help its waters to lie flat.

In the painting, opposite, of a swiftly flowing, shallow stream, my main objective was to capture the feeling of movement in the water. As I felt this could best be achieved by a bold and loose approach, I used plenty of white to represent the water foaming past the rocks and also to indicate the light catching the crest of the ripples.

The effect of the strong current was to produce longitudinal patterns in the water and these I have simplified. Most of the movement was in the centre and towards the nearer bank, while the rather smooth water close to the far bank naturally reflected more of the deeper tones above it. The dark forms of the nearer tree trunks, against the lighter area beyond, not only provided useful contrast, but assisted in the tonal balance of the painting.

The wind ruffled water of the small beck entering on the right reflects the sky overhead.

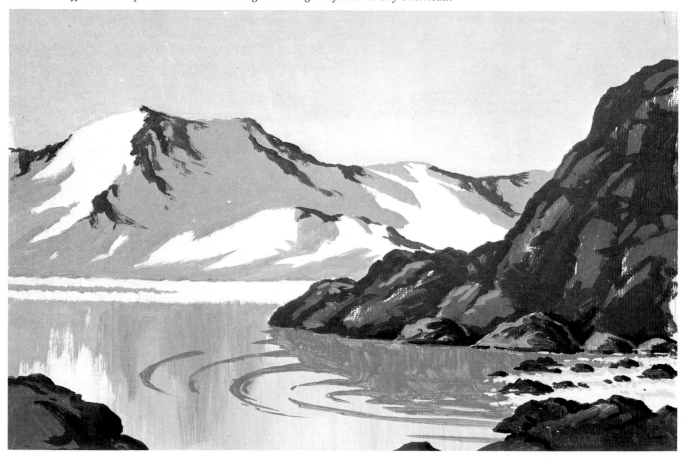

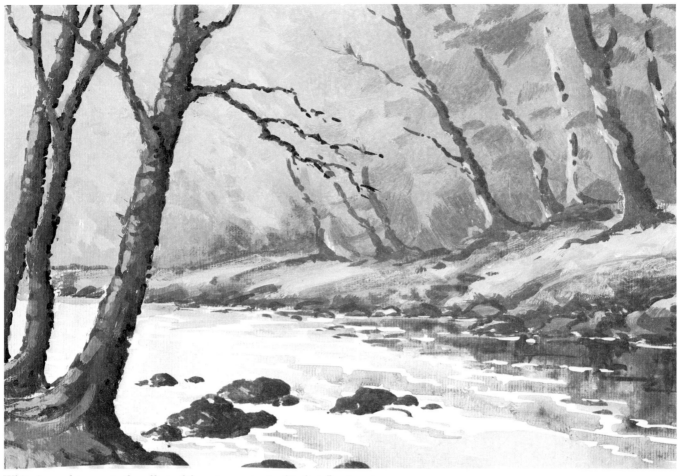

White is used to create the effect of foaming water in this fast-flowing stream.

Fountains

Man has long recognized the decorative properties of water and has used it to improve the appearance of his environment. The great landscape gardeners of the eighteenth and early nineteenth centuries used to dam up streams to create artificial lakes, to construct waterfalls, and build ornamental fountains for their noble patrons. Those entrusted with the improvement of towns and cities also recognized the possibilities of moving water and today many cities of the world possess fine fountains, often combined with statuary, to enhance and dignify their centres.

In this painting of the park fountain, the jets of water, lit by a strong lateral sun, are placed against a dark background of foliage to create lively tonal contrast. The vertical form of the fountain is echoed in the repeated verticals of the tree trunks and balanced by the strong horizontals of the tree shadows. These shadows also provide useful counterchange with the light-coloured pond surround.

Light is reflected in the jets of water falling from the fountain.

55

Stage 1

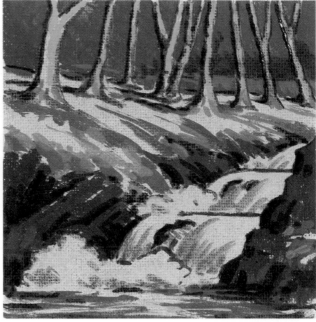

Stage 2

Waterfall: demonstration

Size: 222 mm × 222 mm (9¼ in × 9¼ in)
Paper: fine grain canvas board
Brushes: nos. 7, 8 and 9 bristle
Colours: titanium white, Payne's grey, raw sienna, burnt sienna, light red, ultramarine blue

I wanted to record the smooth arcs of the water as it swept over successive drops. I also hoped to capture the light tones of the spray against the darker rocks and the dappled sunlight against the deeper forms of the trees.

Stage 1
I give the canvas an overall wash of raw and burnt sienna, and allow small chips of this warm tone to persist into the finished painting. Next I sketch in the main construction lines of the composition with dilute Payne's grey.

Stage 2
I block in the rock formations with a deep mixture of ultramarine, burnt sienna and a spot of titanium white.

Then I add a little more ultramarine and white to the same mix and paint in the area of shadow behind the tree trunks.

With varying mixtures of grey/green and brown (respectively Payne's grey, raw sienna, white and burnt sienna with a touch of ultramarine). I next paint in roughly the shadowed areas of grass, and apply the same grey/green to the smooth curve of the water and a little Payne's grey and white to the shadowed areas of spray.

Stage 3 – the finished painting
At this point my object must be to add lighter tones to some of the darker areas, to bring them to life, using Payne's grey, light red and white on the rocks; also in order to indicate algae and moss on tree trunks and rocks, I use a mixture of Payne's grey, raw sienna and white. Next I paint the sun-dappled forest floor with raw sienna, a little Payne's grey and white, and finally put in the highlights on the water and the spray with titanium white and a very little Payne's grey.

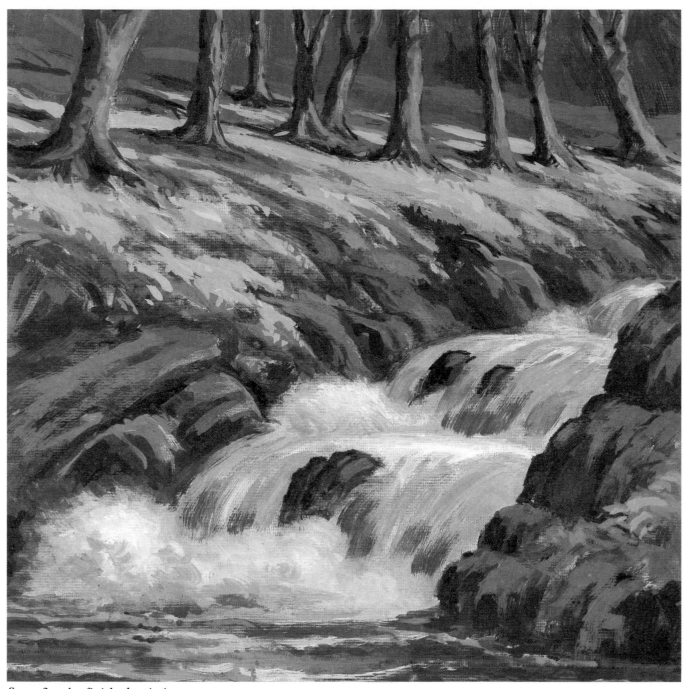

Stage 3 – the finished painting

Still life BY RAY CAMPBELL SMITH AND GORDON DAVIES

Introduction

Commentary and paintings
by Ray Campbell Smith

The term 'still life' is used loosely to denote groups of objects either natural or man-made, or a combination of both. It can include such natural objects as flowers, fruit, or sea shells and range from artifacts such as fine glass and porcelain on the one hand to humble kitchen utensils on the other. The only criterion is the artistic appeal of the grouped objects – does their form, colour and texture produce a pleasing design? The intrinsic value of the objects may have little bearing on this question, for throughout the ages artists have delighted in painting everyday objects and in trying to bring to them a touch of magic and permanence. Such objects may form the centrepiece of a still life painting or may fill the humbler role of props in portrait or landscape paintings. In this chapter I discuss still life as an end in itself.

The basis of all art is sound drawing; however good the painting technique, the finished work will only be as good as the underlying draughtsmanship. This subject and the rules of perspective are covered on pages 16 and 17.

Flower and plant painting is a separate and attractive branch of still life and a chapter is devoted to it later in the book, (see pages 74–89).

Composition

The still-life painter does not have the same difficulties with composition as the landscape painter for he can arrange his subject-matter at will until he is satisfied with the resulting composition.

It makes good sense to group objects which bear some relation to each other and are not just a random collection of articles: this will give your painting point and a motif. Even more important is the need to include objects which, when carefully arranged, will produce a satisfying and balanced design, although some sort of connecting link between them will give the painting added interest. This careful arrangement, or composition, is fundamental to the success of still life work. The objects should be so arranged that they relate to one another, perhaps by overlapping or by being connected by shadows.

Tonal contrast is also important, and is obtained by placing light objects against dark. Above all, the arrangement should have a feeling of balance so that, for instance, the weight and the interest are not all on one side. There is always the danger, however, that meticulous attention to considerations of composition may produce a somewhat contrived and artificial result, so, at the risk of seeming contradictory, try and make a conscious effort to retain spontaneity.

So far I have begged the basic question, 'what is good composition?' One can, of course, say that in a good composition there is a balance and a harmony about the arrangement that is pleasing, but a less vague approach is to list the various pitfalls to avoid.

The most obvious fault is that of placing a dominant object right in the middle of the painting – much better to place it a bit off centre and balance it with something else, (see Figure 1 opposite). Similarly, a dominant line, such as the edge of a supporting table, should not cut straight across the middle of the paper, (see Figure 2). Nor should the objects in a still-life painting be placed in a row – Figure 3 shows how much more pleasing the arrangement will look if the objects are grouped, with some overlapping. The objects need not all overlap, but it helps if there is some connecting link such as a horizontal shadow.

In drawing a group of objects one should always be aware of the position of the margins of the paper or canvas, for these lines have an important part to play in the overall composition of which they are a part. The space around and between the objects is important and the temptation to cram too much on to the paper should be firmly resisted.

Another important consideration is that of tonal balance. The group should not be so arranged that all the tonal weight is on one side. In this context, background tone can be used to effect an acceptable balance, as Figure 4 illustrates. One should also seek to place light objects against dark, to obtain counter-change, (this is explained on page 60 in the section on

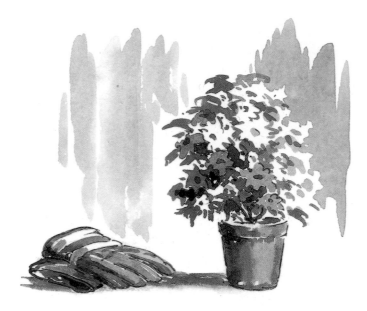

Fig 1
*Placing a dominant object off centre
and balancing it with something else*

Fig 2
*The dominant line should not
cut across the middle of the paper*

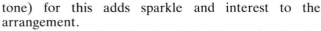

Fig 3
*Objects look more pleasing when
grouped with some overlapping*

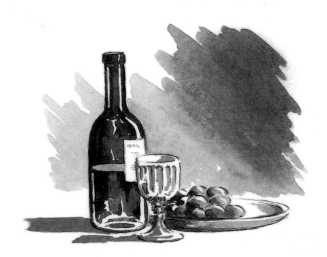

Fig 4
*Background tone can effect
an acceptable balance*

tone) for this adds sparkle and interest to the arrangement.

It is worth reiterating that it is all too easy for the technically correct composition to look somewhat artificial and contrived while more informal arrangements can possess an agreeable spontaneity and freshness. So be on your guard against anything that is too conventional and stodgy. It is a good plan to keep an eye open for good natural compositions and record them in one's sketchbook. A collection of toys abandoned by children may have more to offer than a tight, formal grouping. It is also worthwhile to make sketches of several alternative arrangements of still-life objects for the most pleasing sketch will probably make the best painting.

When you sketch a still-life arrangement, experiment with differing viewpoints, for an unconventional slant can often add interest and originality to a group of mundane objects.

Tone

In the language of art, tone refers to the relative lightness and darkness of objects and not, as in common parlance, to their colour. The success of a painting depends largely on the correctness of its tone values yet, despite this, painters who give long and careful consideration to colour sometimes pay scant attention to tone. However, if the tone values of a painting are correct, that painting will stand up just as well if photographed in black and white.

If you have difficulty in evaluating correct tones, it may help if you identify the lightest and the darkest tones in your composition, and establish these first. The half dozen or so intermediate tones may then be arranged within these two extremes. Difficulty often arises when the darkest paint is used on objects which are not at the bottom of the tonal scale, for there is then nothing in reserve for even darker objects.

In this context still life has one big advantage over landscape painting: for it is a comparatively simple matter to control the amount and the direction of the light falling upon the subject in a way the landscape painter may well envy. The composition can be so

arranged that the highlights and shadows fall where required, thus enabling tonal contrasts to be accentuated. By the same token light objects may be placed against dark, with the same objective in view.

Since acrylic paint darkens appreciably on drying, it is all too easy to allow this to upset tone values. Fortunately with acrylics lighter paint may be added to raise tone without any loss of freshness.

In the painting of vegetables shown opposite, some of the principles I have mentioned have been put into effect. There is, for example, an overall tonal balance and plenty of tonal contrast. The lightest lights – the corner of the window and the highlights on some of the vegetables – are at the top of the tonal scale and almost white. At the bottom of this scale are the deep shadows cast by the objects and by the surface on which they rest. In between these extremes is the range of intermediate tones which helps to describe the form of the group.

In planning this arrangement, I kept constantly in mind the desirability of placing light objects against dark to obtain what is known as 'counterchange', and you will notice how the pale tones of the cabbage and the trug have been set against the dark background. The foreground vegetables, too, make a pale accent against the shadowed side of the trug.

Texture

Acrylic paint is a splendid medium for portraying texture for it lends itself well to a number of techniques that can be employed to produce differing effects. This is not covered in any great detail here, because it is the subject of another chapter, (see pages 90–107); but painters are not only concerned with the tone and colour of their subjects, they need to convey their texture as well. This is particularly true of the still-life painter, for the textures of the objects he paints – some natural, some man-made, vary enormously. Porcelain,

polished wood and metal, for example, all have their own individual gloss while glass presents a unique problem – for not only its shine but its transparency too must be faithfully portrayed. Pay particular attention to its refractive properties and note the distortion of image they produce.

At the other end of the scale are such matt materials as unglazed earthenware and unpolished wood while, between the two extremes, is a whole range of differing textures, each presenting its challenge to the painter's skill and resource. As with so much in art, the starting point must be thorough observation and careful analysis of the surface textures. With glossy materials there must often be some simplification to avoid giving an impression of fussy over-elaboration. It is possible to eliminate much of this problem and ensure, by the careful arrangement of objects, that there is not too much fiddly detail for the shiny surfaces to reflect.

Matt surfaces present an entirely different problem: they reflect very little, although of course even the dullest surface is responsive to reflected light and colour. Careful attention to reflected light will help to impart a three dimensional quality and add a glow to the shadows.

Below, I show a few simple exercises which will help you in this chapter. For more detailed exercises on texture, see page 91. A rough surface can be represented by a scumbling technique, or by the dry-brush application of a lighter tone over a darker background. Successive glazes of thin paint will produce interesting and useful effects while, at the other extreme, heavy impasto work is good for portraying rough plaster or stucco. Painting knives can produce crisp, faceted marks to represent effectively such subjects as foliage and tree bark. In addition to the textured effects below there are many other possibilities. Have a go yourself and see what you can produce with a hog-hair brush, sable brush, painting knife, or even an index finger. You will find it a fascinating exercise and one that will stand you in good stead in all your still-life work.

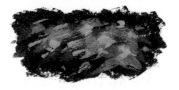

light texturing over darker paint

palette knife impasto

dark glaze over lighter paint

painting dark to light

dry brush work on rough surface

clear liquid wash

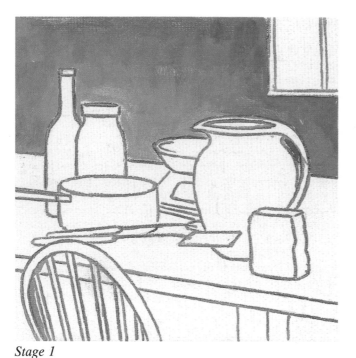

Stage 1

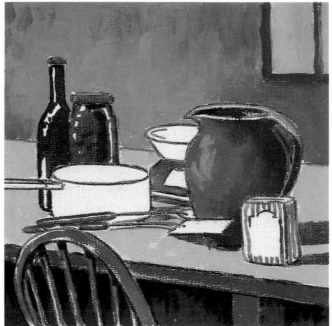

Stage 2

Kitchen table: demonstration

Size: 25.5 cm sq (10 in sq)
Canvas: fine grain canvas
brushes: nos 8, 10 bristle, nos 6, 8 sable
Colours: raw sienna, burnt sienna, ultramarine blue,
Payne's grey, titanium white, vermilion, light red

This demonstration is a collection of work-a-day
objects which one might see on any kitchen table, but
grouped together they provide a pleasing overall
composition and at the same time give rise to a variety
of interesting shapes. The slightly oblique angle of the
table and the contrasting tone and colour of back-
ground and surface contribute to the overall design.
Because the arrangement is fairly complex, the wall
and table surface have been treated as flat planes of
colour.

Stage 1

I sketch the objects in burnt sienna and, simultaneous-
ly, emphasize the shapes of the space between and
around them. At this stage it is comparatively easy to
judge the effectiveness or otherwise of the overall
design, and weaknesses reveal themselves clearly. Here
the design calls for an additional feature to break up the
expanse of green and provide balance, so a small
window is added at the top right of the painting.

For the subdued green of the background wall I use a
combination of ultramarine, Payne's grey and raw
sienna, plus titanium white.

Stage 2

The scrubbed wood of the kitchen table calls for raw
sienna and titanium white. To provide counterchange, I
emphasize the shadow beneath the table, and this also
strengthens the shape of the foreground chair. The
various touches of vermilion, complementary to the
expanse of green, help to lift the painting and give it
life, rather as a small red figure in a predominantly
green setting adds point to a landscape.

The earthenware pitcher is rendered mainly in light
red with a little ultramarine.

Stage 3 – the finished painting

I tackle next the shiny metal objects, for which I use
fairly liquid washes of ultramarine plus a little light red,
leaving the untouched white canvas to stand for the
highlights. The polished metal reflects a super-
abundance of detail which needs considerable simplifi-
cation. The dark green bottle, the jar of preserves and
the shadows falling across the table all require further
attention and the pitcher needs enlivening with burnt
sienna.

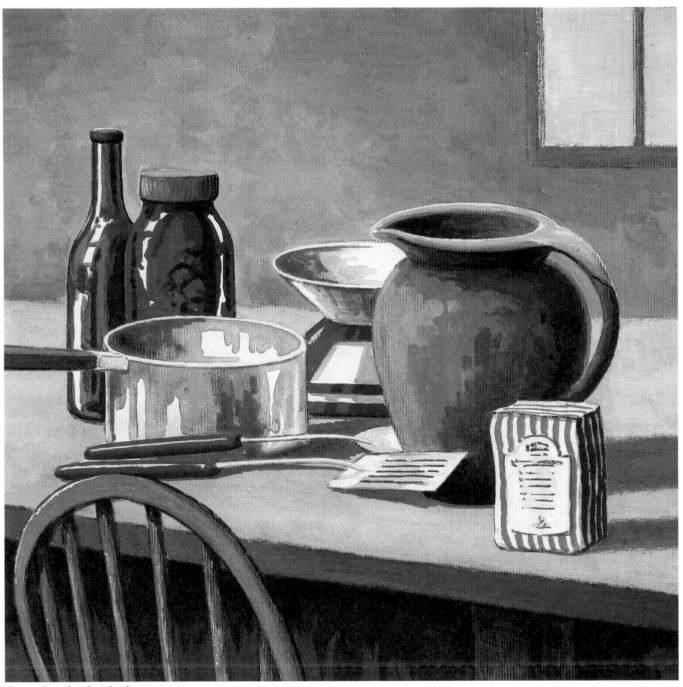

Stage 3 – the finished painting

Light

The quality of light falling on a landscape fundamentally affects the appearance of the scene and hence the artist's response to it. With still-life subjects the quality of the light is no less important although it may often be modified and controlled during the arrangement of the subject-matter. With a collection of three-dimensional objects an oblique light will help to emphasize form and shape while the shadows themselves constitute an integral part of the composition.

As well as delineating form and improving compositional balance, light has an important part to play in helping to establish atmosphere. If you compare the

Mediterranean scene on page 71 with the more shadowy painting above, you will see how the one engenders a sunny holiday mood, but the other produces a more sombre, reflective and introspective atmosphere. In the latter case, the single subdued light barely penetrates the surrounding gloom and focuses attention on the book and the spectacles, to produce a feeling of studious isolation from the outside world.

Though it is simple, there is a balance and a unity about this composition which is analysed in the diagram, or composition analysis, opposite. A successful composition usually resolves into a series of shapes

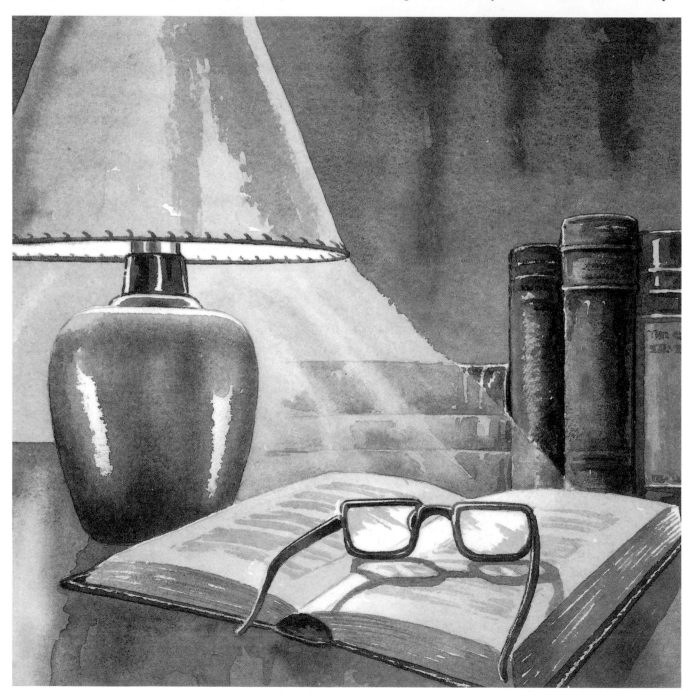

which make up a pleasing pattern. The lines that form the margin of paper or canvas are a vital part of this overall design and have also to be taken into account when the composition is being planned. Here the light area of the lampshade is balanced by the pale pages of the open book and the two are connected by the oblique area of radiance. The rectangle of standing books balances and contrasts with the circular form of the table lamp base, while the spaces between the various objects form interesting shapes in their own right. The gleams of light on the spectacles and on the top of the lamp base impart a spark of life to the painting.

The importance of shadows

In the section on 'Light', I indicate how shadows, and the interplay of light and shade, delineate the form and substance of the chosen composition. Here I want to discuss the treatment of shadows themselves, and there is, of course, a strong link with the earlier sections on 'Colour' and 'Tone' (pages 11 and 60 respectively). This may at first sight seem confusing but, in painting, light, shade, tone and colour are all interrelated. This must constantly be borne in mind, even though, for the

purpose of analysis, they are often treated separately.

Always the darkest paint must be reserved for the deepest shadows and the tones of the lighter shadows carefully assessed. A common fault is that we often give all the shadows virtually the same tone value, thereby robbing the painting of power, vitality and mystery. Shadow tones will vary, depending on their position vis-à-vis the light source and also by virtue of the tone of the surface on which they fall. In addition there are usually tonal variations within the individual shadows, with the deepest near the centre base of the object casting the shadow and the lightest at the shadow margins. There will often be reflected light on the shadowed side of the object itself and this too needs to be given careful attention.

Another common fault of many artists is, as I have said, that of failing to do justice to the rich, if subdued, colours contained in many shadows. They are frequently modified by the colours of adjoining objects, particularly those in full light and those which are strongly coloured.

Such surfaces as polished metal and glass readily reflect light, while opaque and matt materials tend to absorb it. By faithfully depicting the amount and the quality of the light and shade reflected, it is easy to indicate the nature of the material being painted.

As with so much in art, the key is careful observation. To be able to convey a vivid and powerful image, it is necessary to study, to analyse, to assimilate, and to feel.

Above: *shadows are reflected in a hammer and saw.*

Stage 1

Stage 2

Copper kettle: demonstration

Size: 20 cm × 25.5 cm (7¾ in × 10 in)
Paper: Arches 300 lb rough
Brushes: nos 7, 9 bristle; nos 6, 8 sable
Colours: raw sienna, burnt sienna, light red, ultramarine blue, titanium white

Polished copper is an appealing subject for the still-life painter. This old kettle stands by my own fireside, though its object is decorative rather than functional and the same is true of the warming pan hanging on the wall. Together with the wrought iron of the poker, trivet and grate they form a pleasing group by the corner of the hearth, with warm colour and strong tonal contrast.

As the patina of light and shade on the copper was crisp and well-defined, I felt this could best be captured by using liquid washes of acrylic paint rather in the manner of watercolour. This treatment contrasts effectively with the rougher, more solid handling of the old brickwork and logs.

Stage 1

I begin by sketching in the positions of the principal objects of the group, using a small sable brush and dilute burnt sienna. Then I block-in the large area of shadowed brickwork, using burnt sienna, light red, ultramarine and a little titanium white, in order to define the dominant shapes of the composition.

Stage 2

I add the brickwork of the fire recess using a lighter, warmer version of the same mix, leaving a broken edge to accommodate the flames, which are then roughly indicated using raw and burnt sienna. I put in the brick courses with darker paint, keeping the brush strokes fairly rough to suggest old brickwork and avoid anything too tight which might suggest more regular, modern masonry. The fire-lit stone of the floor comes in next with raw and burnt sienna and shadows of light red and ultramarine, all with varying amounts of titanium white. The polished copper is rendered mainly in burnt sienna with light red and ultramarine in varying proportions for the shadows and dark reflections; but I take care to preserve the highlights and keep the treatment crisp.

Stage 3 – the finished painting

The logs are tackled next with a mixture of raw and burnt sienna, ultramarine and white to give a warm khaki colour. Light red and ultramarine are mixed for the shadowed areas and are applied, dry-brush fashion, to indicate the rough texture of the bark. The sawn edges are shown by pale shades of tan and grey and the radial splits in deeper tones. A few final touches and the painting is complete.

Stage 3 – the finished painting

Surfaces and backgrounds

In one's eagerness to arrange a group of objects in an attractive and satisfying manner, it is all too easy to pay too little attention to background and surface. Both, however, have a vital part to play in a successful composition.

First, the surface upon which the chosen group of objects stands. This will usually be a table with, perhaps, some form of covering. I have already mentioned, in the section on composition, (see pages 58 and 59), that an important construction line, such as the edge of a table, should not cut horizontally across the centre of paper or canvas. In all probability this line will be in the lower half of the painting to allow sufficient space for the objects resting upon it. If it is drawn at a slight angle to the top and bottom margins of the support, so much the better.

The second consideration is the table covering. Here much depends on the nature of the still-life articles: if they are complicated in form and colour, a fairly plain fabric should be chosen so as not to compete with the complexities of the objects above it. Alternatively, it could be decided that no covering at all is necessary, although not, probably, if the table is so highly polished that it produces anything approaching a mirror image. With simple objects, patterned materials are perfectly suitable, though care should be taken to ensure their perspective is in harmony with that of the surface on which they stand – not always easy with complex designs.

The fairly complicated forms and colours of the fruit offer a lively contrast to the plain dark background and lighter surface.

Tone is another consideration to be borne in mind, for tonal contrast is vital to the success of any still-life painting. If the objects are light in tone – for example a white porcelain tea set – they will show up better against a dark surface and background. The reverse will apply, of course, if the objects are predominantly dark. If, as is more likely, the group consists of a mixture of light and dark objects, not only should the light be placed against the dark to provide counterchange, but the background and the lighting should be so arranged that here, too, there is tonal contrast.

Curtains and other drapes are often used to provide backgrounds for still-life arrangements. These can be perfectly satisfactory, if somewhat conventional, but it is worth considering alternatives. One often sees still-life paintings in which the backgrounds are just areas of tone and colour, suitable for setting off the objects in front of them, but without any particular meaning. Admittedly, the background should not be so definite that it competes with the still-life arrangement, but in my view it should represent something tangible, otherwise the setting becomes somewhat artificial. This accords with the objective of making still-life arrangements appear both natural and spontaneous.

It is good therapy for the still-life painter to get away periodically from conventional subjects and look for something entirely new. This search need not be confined to the house. Tennis racquets, balls and white sweaters draped negligently over canvas chairs, for example, might make an appealing subject in a leafy garden setting. A group of skis, and gaily coloured anoraks against a snowy backdrop of mountains, could offer an evocative and dramatic painting.

In the sketch on this page, I have taken as my subject the nautical clutter inseparable from the vicinity of fishermen's huts. I came across the scene quite by chance and immediately recognized a natural composition full of character and unusual shapes. The beamy old wooden-hulled fishing boat, the sleeker plastic covered dinghy hull, the ramshackle huts and the assortment of masts, provide a fit setting for the still-life objects in the foreground.

I worked rapidly and loosely, using watercolour brushes with liquid washes which dried rapidly in the warm breeze. I emphasized line here and there with a fountain pen filled with black ink. This use of acrylics, rather in the manner of line and wash, is far removed from the more usual oil-painting approach and shows how versatile this medium can be. With quick-drying washes you simply have to work rapidly, and with the right subject this can give added spontaneity and vigour to your work.

Stage 1

Stage 2

Cretan patio: demonstration

Size: 25.5 cm sq (10 in sq)
Canvas: fine grain canvas
Brushes: nos. 8, 10 bristle, no. 8 sable
Colours: Vandyke brown, ultramarine blue, light red, raw sienna, titanium white, Payne's grey

Stage 1

I begin by sketching the scene in neat Vandyke brown, paying careful attention to the perspective which plays a vital role in the oblique composition. The time is mid-morning and the light clear and bright. If the light were of the warm evening variety I would begin with an overall wash of dilute raw sienna plus a little light red. As it is, I paint the sky, the distant hills and the sea directly on to the white canvas, using varying mixtures of ultramarine and light red, and ultramarine and raw

sienna, plus titanium white. Touches of light red suggest the terracotta roofs.

Stage 2

I complete the middle-distance buildings, using raw sienna and titanium white for the sunlit stucco, and ultramarine, light red and titanium white for the shadowed walls. Payne's grey and raw sienna render the foliage, with added Payne's grey for the cypress trees.

When tackling the foreground, I allow traces of the brown construction lines to show through here and there, thus adding strength and providing contrast with the softer treatment of the more distant view. I then indicate carefully the warmth of reflected light in the shadowed areas of the foreground wall.

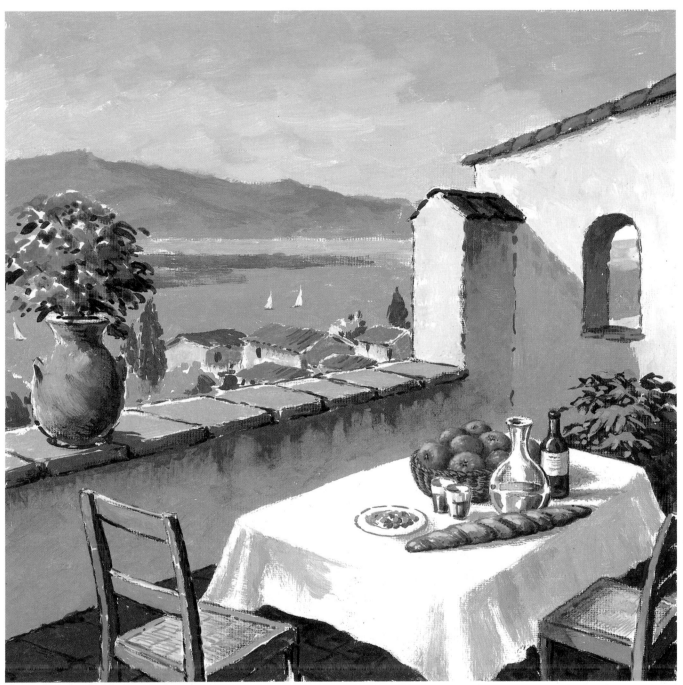

Stage 3 – the finished painting

Stage 3 – the finished painting

It now remains to paint in the foreground objects. The tablecloth is just white canvas, and its shadows are produced with pale ultramarine and light red. The tones and colours I use are designed to convey an impression of strong Mediterranean sunlight in which, of course, cast shadows have an important part to play. Lastly a few flicks of white for the distant sails and the painting is complete.

When I had finished the painting, it seemed to me that the table looked somewhat sparse and the objects upon it rather unconnected. I therefore added a pannier of oranges, a stick of bread and an extra bottle of red wine. Not only do these additions serve to tie the objects together and provide a more harmonious group, but the vivid splash of orange helps to balance the bright colours in the other half of the painting. Second thoughts of this kind present no problems with acrylics for their covering power is such that you just paint over the top.

71

Stage 1

Stage 2

Stage 3

Stage 4

Still life with bugle: demonstration

Commentary and painting by Gordon Davies

For the size of the painting and the colours used, see page 32.

When you choose a subject for a still life almost any object or group of objects will serve so long as the painter has some affection for them or finds that their shapes and colours combine in an interesting way. Try to forget the typical still-life objects and find subjects out of the corner of your eye. So often when you are working on a painting you see subjects unexpectedly and, particularly when you visit another painter's studio, the subjects are all around. The objects at home

seem a little jaded with time and it is helpful to make a note either in the form of a pencil sketch or just a written note to remind you of ideas that present themselves at a moment when it is not possible to settle down and carry out a painting. This painting is of a subject that caught my eye when I was tidying up in the studio: it is the juxtaposition of the ellipses of the jug, the striped mug and the battered bugle that made the subject interesting to me.

Stage 5 – the finished painting

Stage 1

I like to draw out the objects firmly and simply to start with (here on brown primed Bockingford paper) and make sure that the placing is right and the proportions of each object to the other is correct.

Stage 2

I next paint in the shadows using a blue-grey wash. For those without a great deal of experience of painting, this simple step-by-step approach – solving, first, the problems of design and perspective, and then those of tone, before becoming involved with colour – will make difficulties more easy to cope with. Later, with more experience, it will prove possible to telescope the procedure by working in a more direct and immediate way.

Stages 3–4

Notice how, at each stage, work has been carried out in all parts of the painting and no one part brought to full completion while others are left untouched. Take care when painting white objects, such as the lustre jug, that you do not make the general tone too high in key; if you do, it will prove impossible for the highlights to tell with the brilliance that is needed.

Stage 5 – the finished painting

Having established the tonal values of both the assorted objects and the background. I can now apply detail. Mixing my paints to a creamy, opaque consistency, I apply the details and highlights to the four objects of my still life. I then adjust the background and foreground, also with paint of a creamy consistency, yet still allowing some of the original wash to show through in places.

Flowers BY WENDY JELBERT

Introduction

There is nothing more beautiful than the sight of a field of poppies glowing in the sun, or meadows and gardens full of brightly coloured flowers, and as a subject they offer a rich source of inspiration to the artist. Before you start it is important to observe, study and to practise drawing them. Then you will discover the enjoyment of creating lovely flower pictures.

Most of us are fortunate enough to have easy access to an endless variety of flowers, and we are therefore able to study them at our leisure. They flourish in gardens, window boxes, hedgerows, woods, fields and parks; they can be bought conveniently packaged from shops, street corner sellers or the local supermarket and can be used to grace our homes, delighting us with their glorious colours, designs and shapes. As they are so available, it is hardly surprising that artists are stimulated by their richness and variety.

It is only since the seventeenth century that flowers have really become popular as a focus for artistic interpretation. It is worthwhile visiting exhibitions of flower paintings if you have the time. I like studying Jan Van Huysum's enchanting pictures which can be seen at the National Gallery, London; or the rose paintings of Fantin-Latour that I have discovered in my local municipal gallery in Southampton. I also love the less formal flower studies by Beatrix Potter. Artists interpret flowers in different ways and it is up to you to find your own way of expressing their colours, shapes and form.

Acrylic paints are an ideal medium for painting flowers. Their quick drying qualities can be used to advantage and with practise you will be able to apply successive transparent washes of subtly varying colours to their leaves and petals. Also wonderful textural effects can be created using thick impasto work. Grasping the potential of acrylic paint can be great fun!

To freeze the transitory beauty of flowers and to be able to capture their moment of perfection in your sketchbook or painting you will need patiently acquired skills. I hope I can convey these skills to you. It is important to draw and paint as many different types of flowers as you can. With observation and practise you will discover the endless delights of painting flowers.

Above: *when you are painting bluebells into a landscape take care to avoid flat, regimented blue patches which will look very dull. Ultramarine and crimson are used here to create a range of blue and purple tones and the flowers are simply painted in as dots and streaks of colour; practically no detail is shown of the bell-like heads. The foreground clusters are applied with a palette knife. The more distant bells are dotted in with a rigger brush and the leaves are indicated with tapering sweeps.*

Opposite: *unusual props can be used as supports for clinging or climbing plants. Here convolvulus twists and turns around an old wooden post, (see also page 82).*

Petals and flower heads

It is important to understand the structure of any flower you are recreating. The diversity of their shapes, tones, textures and colours have to be studied and sketched in some depth before starting to paint. A finished painting cannot be first class if the underlying draughtsmanship is poor. Drawing and painting are therefore inseparable. You can only capture the fragility of your subject by drawing it correctly in the beginning. Developing and clarifying this understanding will take time and effort and you will most certainly regret your haste if you try to skip this essential stage.

Choose a small assortment of petals and flower heads in a variety of colours and shapes. Now, with 2B and 6B pencils, sketch them on to a sheet of cartridge paper, or use your sketchbook. My class students will readily dissect a flower head so they can study its structure in detail. They will then draw the single head from several different angles. The confidence gained helps them tremendously when more complex flower studies are tackled.

Flower forms can be recognised in terms of a series of geometrical shapes. Most are based on cylinders, pyramids, spheres and cones. Below, in Figure 1, I show how a shallow cone forms the basis of a simple daisy. In Figure 2, I show how the bluebell can be based on a simple pyramid. A compound flower, such as a fuchsia, or the daffodil shown in Figure 3, can be constructed from a combination of cylindrical and conical shapes; the smaller forms slot into, or are enclosed by, the outer ones. Study the flowers in your own garden and practise extracting framework sketches

of their structure. Simple blooms can be analysed in this way. But if you want to paint flowers with a more complex structure, you will have to rely on your own powers of observation.

When you are satisfied with your drawing, it is time to start to experiment with your colours. With or without a preliminary drawing, paint the petals and flower heads using the illustrations opposite as a guide.

Leaves

Leaves are an integral part of the whole flower, and therefore require the same attention to detail as the flower heads and petals. You must also take special care to ensure that the proportions of the flowers to the leaves are accurate, or the finished painting just won't look right.

Whatever the nature of the leaf you are studying, its basic form can be analysed as a simple shape. I have already shown this when describing the petals and flower heads. Circles, triangles or rectangles can be used to build up the basic form.

Once you have established the correct design, you have to then consider the possibility of drawing or painting several or many leaves. Their massed shapes can be an essential dramatic foil to your flower study. Rhythmical lines can be created by arching and pulling the leaves in various directions.

First of all, choose several leaves of different sizes, shapes and colours, and practise drawing them individually before starting to paint. As well as ready mixed greens, such as viridian, Hookers green and olive green, you will need to mix some of your own using blues and yellows. Below I discuss how you can construct a simple exercise which should help you to solve any problems you may have with leaves and foliage.

Take a clean piece of paper; gather together your ready mixed greens and mix some of your own using blues and yellows. Place these colours down the left-hand side of your paper. Then place crimson, burnt sienna, orange, pink and deep purple in a row along the top. Now modify each green in turn with each of the top colours. Mix equal amounts of each colour in all cases, working through the whole block. You will discover some lovely subtle and useful greens. If a darker green is required, thicker paint is needed.

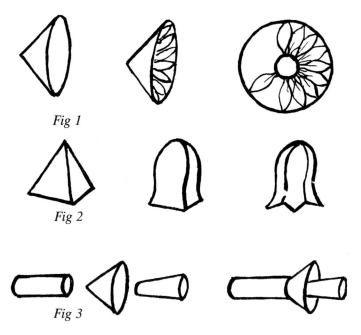

Fig 1

Fig 2

Fig 3

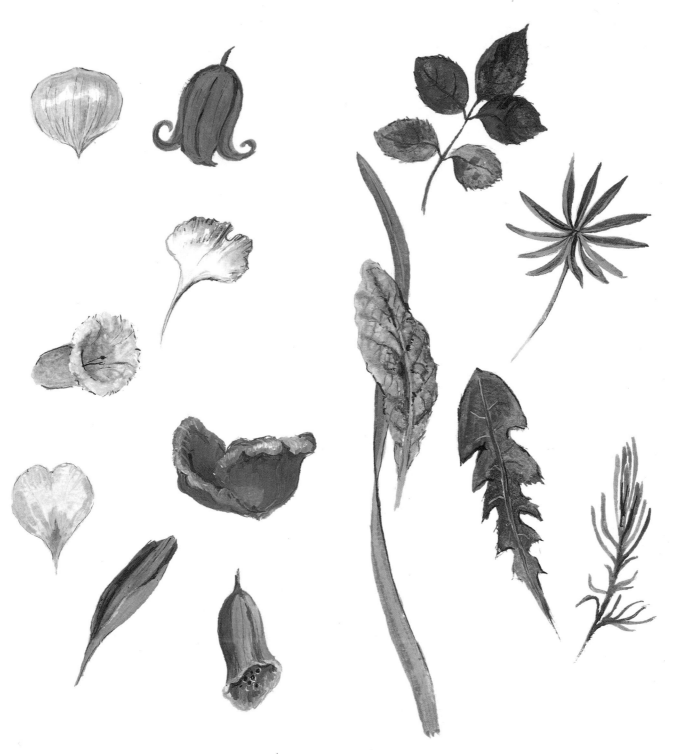

Confidence can be gained by studying individual flower heads, petals and leaves. Here I have chosen a small assortment in a variety of shapes and colours. Practise a few pencil sketches, then try using colour. This will help you when you tackle the more complex flower paintings in this chapter.

Chrysanthemums: demonstration

Size: 24 cm sq (9½ in sq)
Paper: rough watercolour paper
Brushes: no. 6 ox-hair, no. 1 rigger
Colours: ultramarine blue, olive green, white, light red, cadmium yellow, crimson
Other materials used: rag, palette knife, gel medium

The chrysanthemum is the national emblem of Japan. There are many different varieties of this star-like flower. The Incurved, Reflexed, Pompon, Thread petal, Double and Single are just a few of those that you may come across at almost any time of the year. It is almost impossible to believe that all the different varieties originate from one small blossom that was brought over from the Far East long ago.

With new varieties still becoming available, it is small wonder that these highly popular blooms are of interest to the flower painter. They last exceptionally well when cut and placed in water, so there is no need to panic when attempting to paint them!

I feel that these flowers lend themselves particularly to an oil technique, and have used this approach to create my final painting opposite.

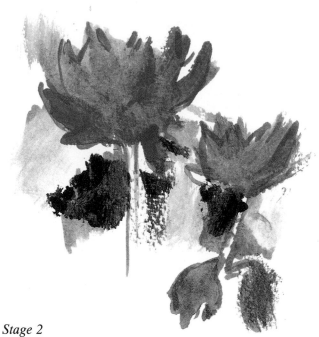

Stage 2

Stage 2

Using a rag, I roughly fill the flower shapes with light red and the leaves with olive green.

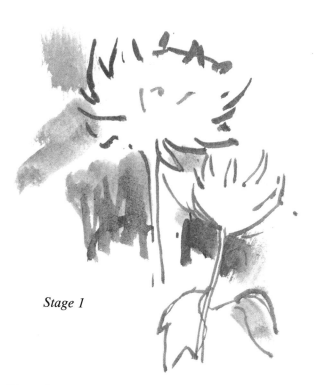

Stage 1

Stage 1

I begin by outlining the flowers and blocking in the background using bright blue. I intend for this to peep through successive layers and become a feature of the final painting.

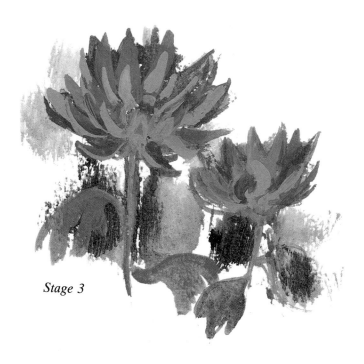

Stage 3

Stage 3

Working with the palette knife, I paint over the darker base, adding in pinks and pale yellows. I leave some of the base colour to show through; the areas of deeper shade in the flower heads are thus depicted.

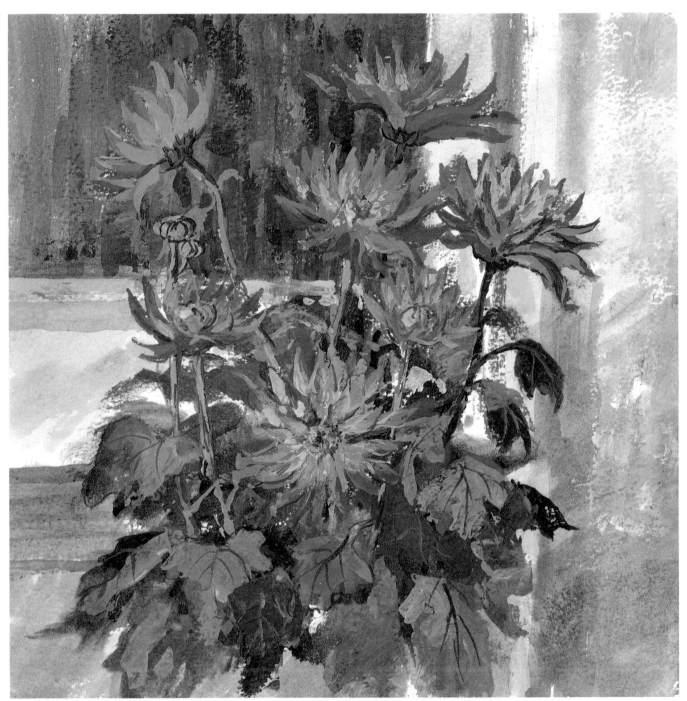

Stage 4 – the finished painting

Stage 4 – the finished painting

Using the rag I apply various colours to the background in areas of differing tones to indicate the wall and the window. This creates the illusion that some of the flower heads (those backed by the darker blue window) appear to be lighter in tone than those that have the paler wall behind them. This is a really fundamental technique and one that always adds something to a work. It produces an apparent extra dimension in the tonal range of the finished picture. Next I mix colour variations of yellow ochre with ultramarine. Using the ox-hair brush I complete the lighter leaves; olive green is the predominant colour used for the darker leaves.

To complete the petals I carefully outline some of them with light red and strengthen those around the central buds with the same colour.

Finally, I use my palette knife to improve the finished work. The knife, fully charged with pale yellow (the flower colour) is pulled down and over the wall area on the right hand side of the picture. The pushing of this subject colour into the background gives a sense of unity to the picture, helping to solve a problem that many would-be flower painters experience.

Note – the glimpses of blue that can be seen amongst the foliage are still preserved from Stage 1.

Props

Unless you are using a purely illustrative style, you will probably want to include some sort of accessories in your flower picture to create atmosphere, stability, or even decoration. If you use a container, choose it carefully so that its shape and colour will harmonise with your chosen flowers. Be imaginative; don't always use the same one. An enterprising flower painter will start a collection of suitable objects that will complement his or her work.

As well as the container, consider the addition of other props – perhaps a mirror to create another dimension, or a shelf that could break the blankness of a simple flat base into two levels. There are many possibilities.

Glass can be quite difficult to interpret as it absorbs and reflects surrounding colours. In the painting below there is an intriguing distortion of the jar's contents. Before you start on a subject like this, observe these effects carefully: the interlocking areas of colour, tone and form combine like a jigsaw puzzle. Analyse them in your own way. The highlights in a scene like this may not be as white as you may at first think. Do not make them too stark.

In the carnation painting above, I have placed two blooms on a white lace trimmed tablecloth. You will note that I have toned the tablecloth down and introduced soft, interpreted reflections of pinks and blues.

I start by drawing the carnations and basic form of the lace patterns with a 3B pencil. Then, using a ruling pen, I apply the masking fluid to the intricate parts of the lace and I highlight the flowers. When the fluid is dry, I paint in thin washes of violet and blue over the background, the shadowed areas of the cloth and the foreground. I gently deepen the tones of the lace that lie beneath the carnation in the foreground. When the masking fluid is removed, the lace pattern appears slightly more prominent than the surrounding areas. Finally, using my rigger brush I add more detail to the lace patterns with purples and blues.

Urns and tubs

Here I concentrate on outdoor subjects. You should be able to visualise your chosen flowers in a variety of settings – primroses on a patio in a terracotta pot, or nestling in a hedgerow for instance. With practise, you will soon be able to imagine these location cameos into which your flowers can be set. Look around you. Seek out interesting nooks and crannies and record them in your sketchbook for future reference.

Both the pictures on this page are from my sketchbook. When deciding on your container remember that it must act as a foil, quietly complementing, and never dominating the plant it holds. Let us start with the weathered stone urn. I pencil in its basic shape and surface design. I then apply an initial wash of diluted yellow ochre and while it is still moist I use a toothbrush to 'splatter' olive green and light red in small areas, giving a realistic pitted and rough look.

With a rigger brush I complete the detail of the pot's surface decoration. Here I use olive green and crimson in the shadowed area and the recesses of the scrolled and fluted forms. The highlights can now be superimposed with dryer white and crimson plus a touch of yellow.

Although the tub is easier to draw than the urn, it is still important to be careful with the drawing. The bands that bind the tub together must all follow the same gentle curve. Here I have arranged the flowers so they tumble over the edge of the tub to soften the hardness of its edges. This also helps the blooms to retain their dominance over the container. I use blue, light red and olive green for the bands and paint in the grain with a rigger brush using dark crimson and olive green.

Using natural surroundings

You will have to become a keen opportunist to capture some of the beauty and delights of nature: a bee alighting on a flower petal, a butterfly teetering on a bud, or a spider's web glistening like glass.

Here I have incorporated a web into one of my bramble paintings. It is highlighted against a background of dark foliage, part reflecting the light. I found the easiest way in which to tackle this complicated web was, after the initial drawing, to home in with a drawing pen and painstakingly cover the detail with masking fluid. When it was dry I painted in the background. Then, making quite sure that the background was dry, I briskly rubbed off the masking fluid, uncovering the virgin white paper beneath. A transparent wash assured that this blended gently with the surrounding areas.

Another alternative is to paint in the background first, then when this is dry, the web can be constructed over the top with a rigger brush, using white paint.

The 'props' that really delight me are those that are unusual or hidden away; the fence, the broken gate post or the dead stalk supporting a clinging or climbing plant like the honeysuckle or ivy. In the painting opposite a wooden arch supports a mass of rose heads and tangled foliage. In the picture on page 74, I have painted some convolvulus twisting around an old post complete with rusty catch! Search for intriguing and unusual frameworks for your plants and practise drawing and painting them in your sketchbook.

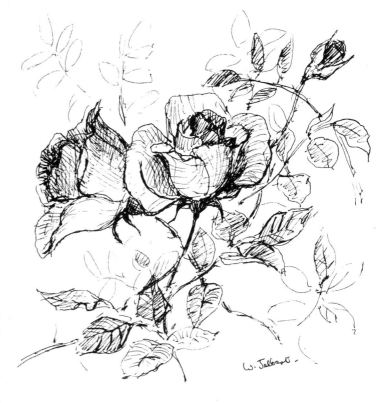

Pen and ink study of roses.

82

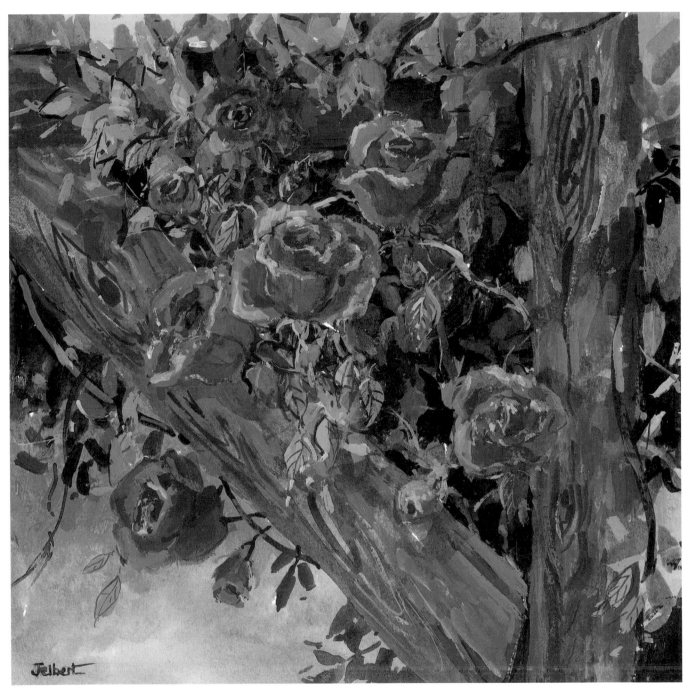

A wooden arch provides a perfect setting for this lovely group of roses. Variations of yellow ochre, Hookers green and light red are used on the arch; the texture is drawn in with a rigger brush. The leaves are painted in with a range of ready mixed greens and the flower heads are built up over a wash of yellow ochre with light red and vermilion run in. Deeper shadows are added using crimson and Hookers green with the wash peeping through, and crimson and white are used on the lighter areas.

Dandelions and thistles: demonstration

Size: 28 cm sq (10½ in sq)
Paper: watercolour paper 140 lb
Brushes: no. 6 hog-hair, no. 8 ox-hair, no. 1 nylon rigger
Colours: white, yellow ochre, Hookers green, cadmium yellow, ultramarine blue
Other materials: palette knife, masking fluid, old toothbrush

Often a painter will want to include two or more different flowers in a picture, but it may not always be possible to find them naturally growing together, or forming a suitable composition. I often take bicycle rides through my local lanes seeking inspiration and new ideas. I make mental notes of any attractive or promising places that are worth a second visit, especially if there are plants growing there that will blossom later in the season. On one such adventure I found the flowers for the painting opposite. I was fascinated by the golden yellow dandelions with their delicate seed heads like misty orbs, and by the wonderful way they contrasted with the tall spikey thistle with its violet blue flower.

Stage 1

Stage 1

I use a soft pencil to sketch in this fairly complicated flower arrangement, and splatter masking fluid on to the three dandelion clocks with an old toothbrush. A wash of yellow ochre is applied to the background, leaving the white seed heads untouched. Using the squirrel-hair brush I block in the blue sky, then place the leaf shadows in the foreground with yellow ochre and Hookers green. Working quickly, I paint in the yellow dandelion heads, allowing them to blend into the still wet background colour.

Using white I quickly glaze pale circles over the darker area on the right to represent the seed heads. I accentuate the bud on the left and a few stems with Hookers green, then paint over the dried masking fluid with a little green. Finally, I dot in the thistle heads in the background with Hookers green and light red.

Stage 2

The composition is now established, but the bands of texture require more detail. I enrich the dark thistles with ultramarine and light red and complete the spikey decoration with the rigger brush. As I feel the foreground could be darkened a little, I block in some leaf shapes using a mixture of light red, blue and green. I now rub off the masking fluid and paint in the delightful pink stems of the dandelions.

Stage 2

84

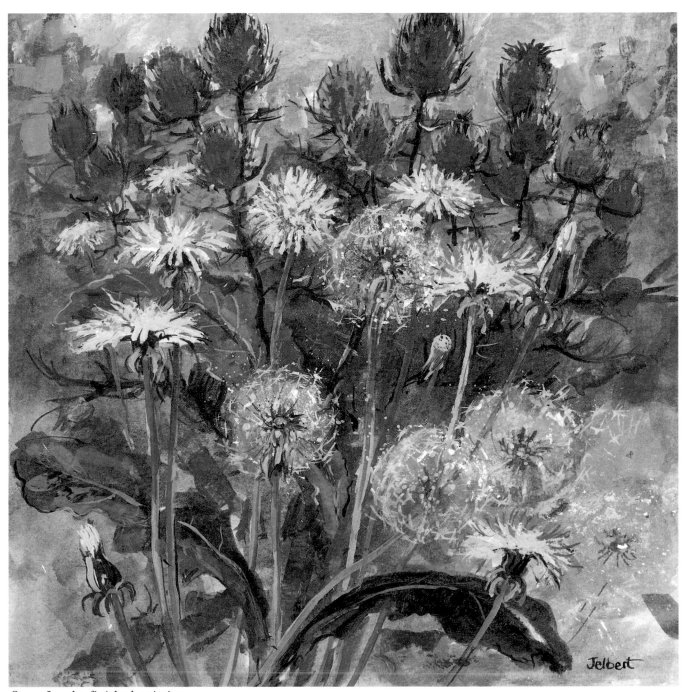

Stage 3 – the finished painting

Stage 3 – the finished painting

Now I have to draw in the final details and tie up the rhythmical tonal areas of the picture. With a glaze made up of Hookers green, ultramarine and a touch of light red, I cover the middle distance, bringing into sharp focus those brilliant yellow heads with the now shady depths beneath. Using a palette knife I apply yellow ochre to the flower heads in regimented lines, giving texture and form to the individual petals. In the foreground the large leaves are reinstated with the palette knife and the leaves behind are made to recede by painting over them with their own colour mixed with yellow ochre. I use the ox-hair brush for this. Finally I carefully add tiny blue and white star shapes to the delicate seed heads with the rigger brush.

Do not completely cover the original yellow ochre wash, but allow small specks of it to gleam through. This will enliven the surface and give it a unifying warmth.

Backgrounds

I believe that this section will be of special interest to every painter. There are many subjects (not only flowers) that require the careful choice of a sympathetic background. Your flower painting will have more impact and will give you greater satisfaction if you can successfully overcome the difficulties of selecting the content, tone and colour.

It will not do to just slap any old colour on to the background, hoping for the best! The background provides the setting that will embrace and enhance your subject. It will influence every step you take in the progression of your painting.

The foreground objects must have an affinity with the background and in any painting you should always develop your background and foreground as one unit. This allows the scene to unfold and progress as a whole. In many cases, the blooms and the background can be painted over with the same first wash, exuding a feeling of oneness. The background must not merely surround the flowers, but must contribute some atmosphere and

sparkle of its own.

The painting above shows a clematis against a dark yellow brick wall. The colour and texture of the background flatter and highlight the beauty of the flowers.

The paintings opposite show the same bunch of white tulips with different backgrounds. The top left painting is a study in contrasts. The tulip heads in the light of the window appear darker than those in the adjacent painting. These appear to have been made lighter by the darker fabric behind, even though in both paintings the tulips are the same colour. In a multiple subject like a bunch of flowers, the blooms can be remarkably alike in colour and tone. This technique can therefore force much needed extra contrast and variety.

In the top right painting I have simplified the tulips and placed them in front of a brightly coloured material. The lines and flow of the design form an intricate pattern in which the tulips are of secondary importance.

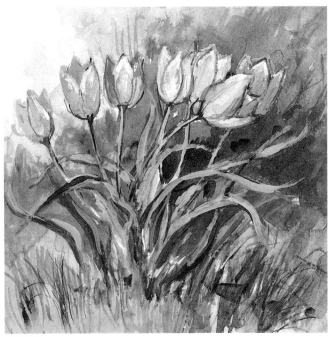

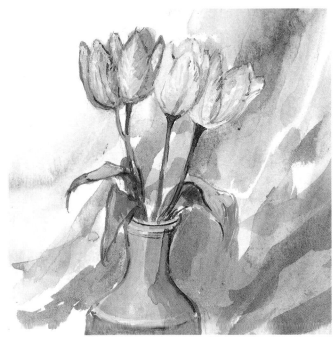

This is a useful exercise for the student. The use of an extravagant background will help you to select the more important features and leave out others when tackling a scene which would otherwise be cluttered and overbearing. Acrylics are excellent for this kind of experimentation. Layers can be added, mistakes obscured with white and quickly repainted, and delicate washes applied to soften and diffuse hard edges. The speed with which images can be created and then demolished at a whim is incredible!

In the bottom left painting I have placed the tulips in a natural sunlit setting. If you are lucky enough to have them growing in your garden, then painting them 'in situ' is even better. All the ingredients are there just waiting for your attention – atmosphere, lighting and background. In my painting the character of the setting is sufficiently subdued in colour and tone so as to avoid the flowers being dominated. Notice how the sunlight throws the leaves into bright silhouette. The patch of shadow in the background helps to give this impression.

The final painting, bottom right, is a perfectly traditional setting. The tulips are displayed against the restrained pattern of a length of material which is arranged in attractive folds in the background. These folds should not conflict with the fundamental compositional forms of your flowers, but should harmonise with them.

Stage 1

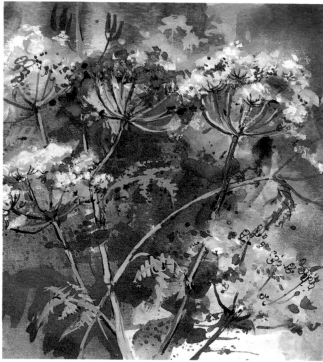

Stage 2

Cow Parsley

Size: 27 cm sq (10½ in sq)
Paper: watercolour paper 140 lb
Brushes: no. 10 hog-hair, no. 4 squirrel-hair, no. 1 rigger
Colours: light red, olive green, yellow ochre, ultramarine blue, deep violet, white
Other materials: black waterproof ink to sharpen the detail

The sheer elegance of cow parsley, this true proclaimer of spring, never fails to inspire in me a feeling of real tenderness. For this demonstration I use the two photographs seen here, integrating them to create the final painting opposite. From the photograph below left, I extract the trees, elaborate on them, and then balance the composition by placing the clump of ivy on the left in the middle distance. I then use the close-up photograph as reference for the plants in the foreground. If you only have limited time on an outing, a camera and a sketchbook can be used to provide a wealth of material which can be referred to all year round. I often staple any photographs I take into my sketchbook, along with the relevant sketches.

Stage 1

I omit the pencil drawing stage this time and, on wetted paper, go straight to work with the hog-hair brush and apply a wash of yellow ochre. Into this I drop variations of a mix of olive green and violet, cooled with a touch of ultramarine. I also add thick blobs of white that bleed attractively into the darker surrounding colours to form the basis of the cow parsley shapes. Next, while the colours are still wet, I apply black ink to the central

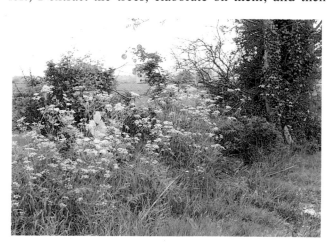

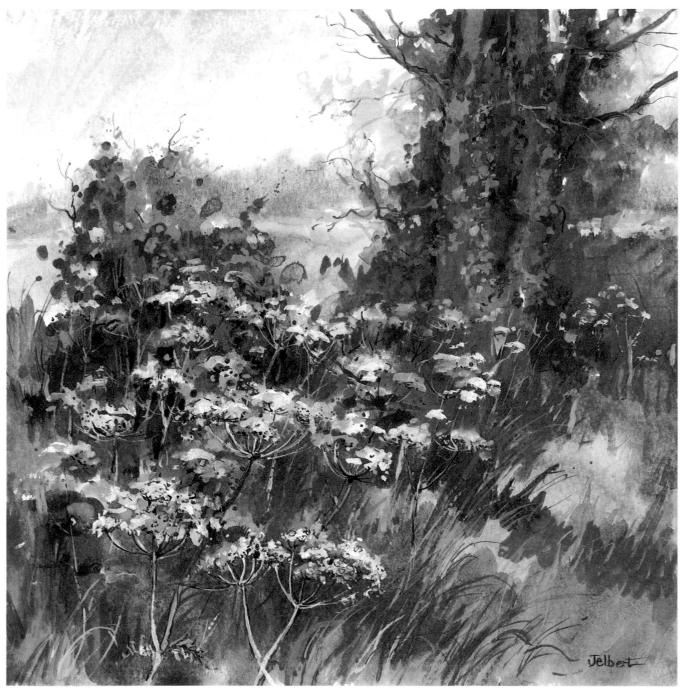

Stage 3 – the finished painting

area, priming it to take the lighter details of the plant in the next stage. If you succeed in doing all this quickly enough, I hope you will discover for yourself how spontaneous and free this wet in wet technique can be.

Stage 2

I now start to paint in the details. Using light green and the rigger brush, I add the slim stems which criss-cross each other. I draw in the central darker flower head using pen and ink; some delicate penwork is also added to the lighter flowers around it. Using the squirrel-hair brush I paint in the feathered cow parsley leaves with olive green and yellow ochre. I add touches of white to the lacy flower heads.

Stage 3 – the finished painting

To create the final painting I use all the techniques described in stages 1 and 2. As I lay down the first wash of yellow ochre, I add an expanse of ultramarine and white to the sky area and, before it dries, quickly paint in the distant misty trees with blue and light red. The two dominant trees are embellished with ivy, using a variety of dots and stabbing marks in varying hues of light red and pale yellow-greens. A band of light green is ribboned through the background, gently silhouetting the middle distant features. Notice the lively dots and strcaks of light red that are flicked into the grasses. They break the monotony of a picture that could otherwise be too green.

Textures BY WENDY JELBERT

Acrylics are ideal for impasto and textural effects. Given a favourable temperature and humidity, they dry very quickly and layer upon layer of paint can easily be applied. I have been experimenting with textures successfully for some time and apply all sorts of objects to a painting to achieve a desired effect. Because of the

Detail of the painting on page 103.

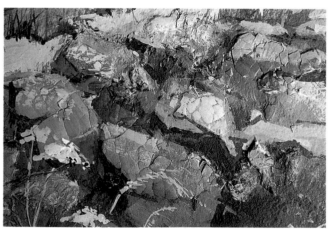

Detail of the painting on page 105

adhesive qualities of acrylics, a modelled and textured effect can easily be created by embedding tissue paper, grit, sand – or even egg shells – into the surface.

All the exercises opposite are suggested merely as guidelines. Be as daring as you want but do be careful – the effect you achieve has got to bear some relevance to your painting! When applying materials to the surface, I always glue them in place after I have done the intial drawing. Ideally, it is better to let the prepared surface dry out overnight.

Top left: thick glue is dribbled on to the paper in patterns; let the glue dry thoroughly before applying acrylic paint. This effect can be used to add texture to seaweed, rocks or sheeps' fleece. I have used this technique in my 'sheep' painting on pages 106 and 107 to demonstrate how effective it can be.

Top right: for a gritty texture, I dab a thick layer of glue on to the paper, then press grit well into it, so it adheres to the surface. Let the whole surface area dry before applying any paint. This effect can be used to add texture to rocks, gravel paths or sandy shores. I have used this technique in the demonstration painting 'Sand dunes and sea-gulls' on pages 102 and 103, a detail of which is shown on this page.

Centre left: sand is applied in exactly the same way as the grit. I sprinkle it gently on to the glue, then carefully blow the excess off before letting the whole area dry. Paint is then applied. This is a delightful texture to use for a sea scene, or foliage to create a stippled effect. It can also be combined with tissue paper (or other materials) to add texture to mountains and stone walls.

Centre right: this interesting surface is obtained by applying thick white acrylic paint to the paper using a palette knife. Care has to be taken with your sculptured composition because once it has dried, it is impossible to change, except by adding more texture! The sharper, lighter edges jut up through a very watery acrylic wash, giving a lovely gentle effect. This can be used to add texture to tree bark, tiled roofs and foliage; or you can, as I have in my painting of 'The old gate' on page 101, use it to give the appearance of rough, textured stonework on a white-washed wall.

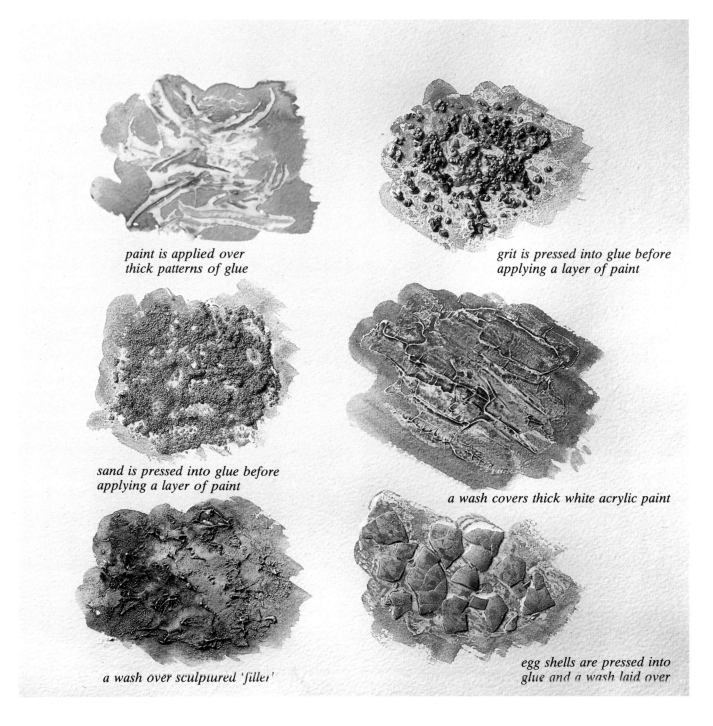

paint is applied over
thick patterns of glue

grit is pressed into glue before
applying a layer of paint

sand is pressed into glue before
applying a layer of paint

a wash covers thick white acrylic paint

a wash over sculptured 'filler'

egg shells are pressed into
glue and a wash laid over

Bottom left: a quick-drying D.I.Y. 'filler' gives this lovely effect. It is available in an unmixed powdered form, or ready-mixed in tubs or tubes. Either can be used and applied to the paper using a palette knife, brush or even fingers. It is malleable and can be formed into whatever shapes you choose, but be careful and plan your texture well for it dries very quickly. An acrylic wash is applied over the dried surface highlighting the roughness.

Bottom right: here egg shells are broken into small pieces, pressed well down into a layer of glue and allowed to dry. An acrylic wash laid over the dried surface accentuates the highly textured effect. This technique is best used to add texture to crazy paving or stone walls and I have used it effectively in my painting 'Cornish stone wall' on pages 104 and 105, a detail of which is shown opposite.

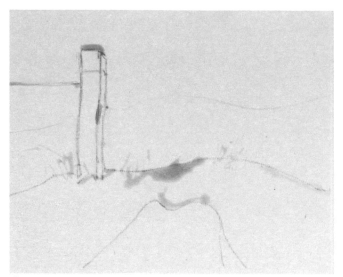

Stage 1

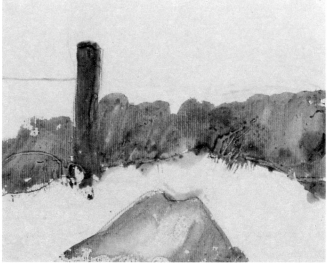

Stage 2

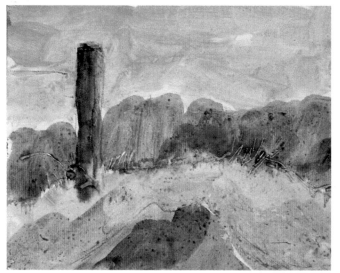

Stage 3

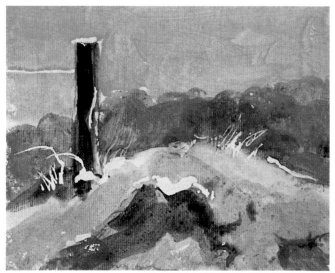

Stage 4

Snow scene: demonstration

Size: 35.5 cm × 28.5 cm (14 in × 11¼ in)
Paper: fine grain oil-painting paper, 300 gsm (140 lb)
Brushes: no. 6 hog-hair brush, 13 mm (½ in) ox-hair brush, no. 1 rigger brush
Colours: yellow ochre, Vandyke brown, cerulean blue, white
Other materials used: 2B pencil, ruling pen, masking fluid

It is important to remember, when embarking on a snow scene, that although the predominant colour may at first sight appear to be white, in fact there are many subtle variations of tone and colour. Soft pastel pinks, apricots, yellows, purples and greys are just waiting to be discovered – even over-emphasized or invented to make the painting more exciting! Imagine each shape and colour having boundaries which slot together gently like a jigsaw puzzle.

Stage 1
With a 2B pencil I sketch in the principle lines of the composition. Using a ruling pen, I apply the masking fluid along the barbed wire, over the grasses and brambles on the base and top of the fence post and across the top of the snow mound. I allow the masking fluid to dry before going on to the next stage.

Stage 2
Using a mixture of cerulean blue and Vandyke brown, I paint in the distant wood and the dip in the snow in the foreground. I then drop a darker tone into the distance whilst the paint is still wet. The fence post is painted in using Vandyke brown.

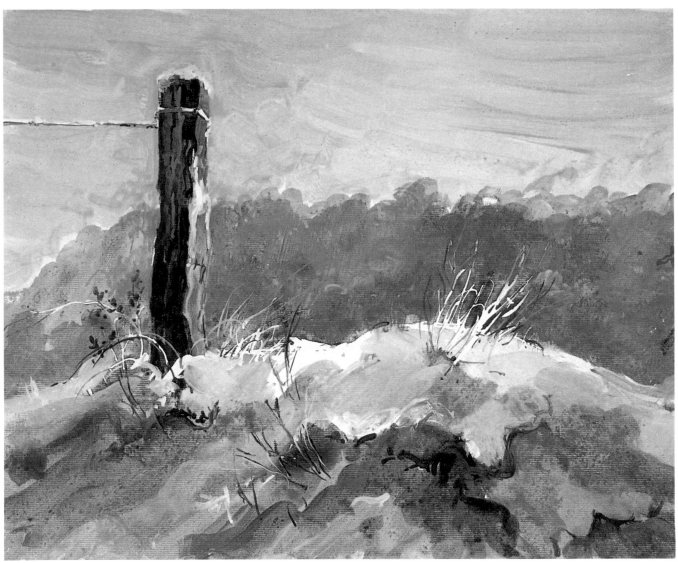

Stage 5 – the finished painting

Stage 3

Because of acrylics' quick-drying properties, there is no problem with smudging. I often place the sky in at a later stage, as I have here, using a mixture of cerulean blue and white. Yellow ochre is then washed over the top of the snow mound, and when dry a touch of blue is glazed over it. I blend more blue into the foreground fold of snow.

Stage 4

Allow the paint to dry thoroughly before briskly rubbing off the masking fluid. A lovely random textured effect can be achieved by splattering masking fluid on to a painting with an old toothbrush. Experiment with another snow scene – it is great fun! I darken the shadows on the fence post with cerulean blue and Vandyke brown. A darker blue shadow and a glaze of white are added to the foreground snow.

Stage 5 – the finished painting

Most of the white forms, which result from expelling the masking fluid, need to be painted back into the picture. Some areas can be left untouched and used to portray snow on grass and bracken as well as highlights on the central snow mound. I make the shadows on the post darker again using cerulean blue and Vandyke brown and a darker blue shadow is applied in the foreground snow. I add snow and light blue highlights to the fence post and with Vandyke brown I paint in details of the bracken and branches springing out from the snow in the foreground.

Foxgloves

I sketched this scene when I took my art class on a trip to the New Forest. Part of the wood had been cleared, leaving several tree stumps jutting up from the forest floor. Dotted amongst these delightful shapes were tall, elegant foxgloves. The sun fell into the clearing, highlighting several contrasting textures – the rough bark, the stubbled grass and leaves and the delicate pink flowers.

I always take photographs as well as sketching, then staple them into my sketchbook later on; this provides excellent reference material for future paintings. Here I show the tonal sketch which was made before deciding on the final composition. Artistic licence is often used when sorting out compositional 'hiccups'. Often I do not like the way objects are arranged and moving them around into more acceptable positions is an advantage we artists have over our photographer friends! If you are working from a photograph only, try out 'thumb nail' sketches first and this will prevent you from making mistakes in your final picture.

This painting is about contrasts and textures. Checking carefully with my sketchbook. I note the juxtaposition of the tonal areas. Without these being properly balanced, I would not be able to capture the illusion of sunlight and shade. The main features of the painting are sketched in using my photograph and sketches as a guide. I than apply a yellow ochre wash over the whole drawing.

I make a quick sketch, noting the tone and texture of the tree stump.

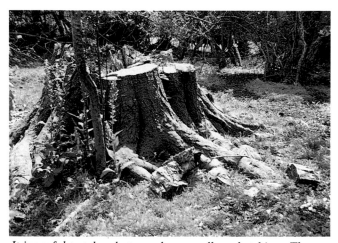

It is useful to take photographs, as well as sketching. They provide excellent reference material for future paintings.

The background trees are painted in with a mixture of olive green, cerulean blue and a touch of alizarin crimson, allowing glimpses of the yellow ochre to show through to give warmth and unity to the scene. For the greens in the picture I use mixtures of ready-made greens straight from the tube and greens I have mixed myself using blue and yellow.

The sharp textured bark of the tree stumps is built up using cerulean blue, yellow ochre and various greens. Taking a sponge, I dab it into the paint, then transfer the colour on to the painting to achieve a 'broken' effect that would be impossible with a brush.

The central pink flowers, painted in alizarin crimson and white, and the accompanying green foliage, are cradled by the deep shadows of the tree stumps, whilst the other two flower groups are in contrast with the sunlit middle distance, being darker and bluer in colour.

A palette knife is used on the tops of the stumps, the roots and some of the spiked leaves of the foxgloves. Expressive brush strokes using the hog-hair brushes give a feeling of texture to the flowers, areas of the bark and the leaves. The deep crevices of the bark are painted in using a rigger brush.

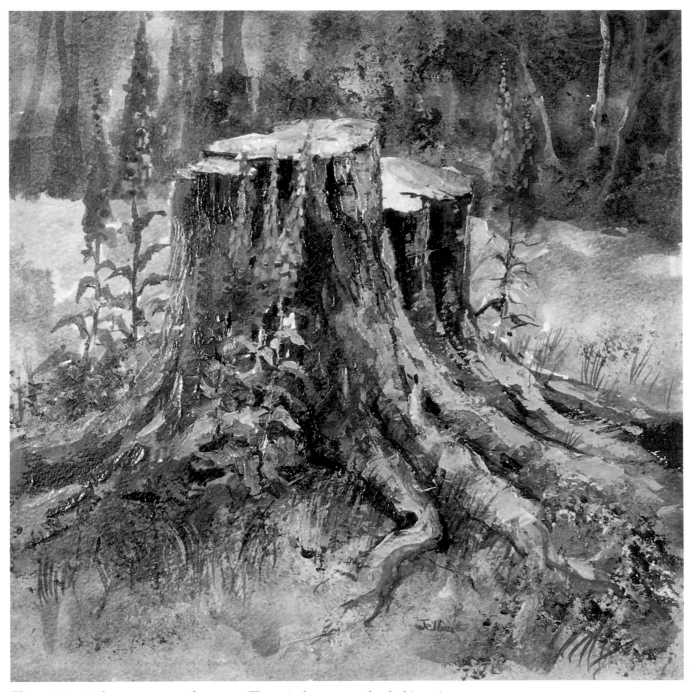

This painting is about contrasts and textures. The main features are sketched in, using the photograph and sketch as a guide. The sharp textured bark of the tree stump is built up using several colours. A 'broken' effect is achieved by dabbing a sponge into the paint before it is dry.

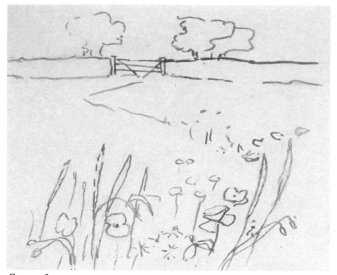

Stage 1

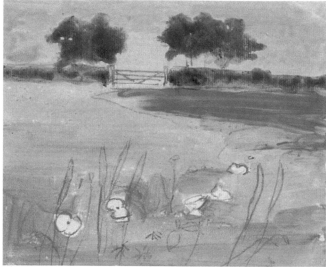

Stage 2

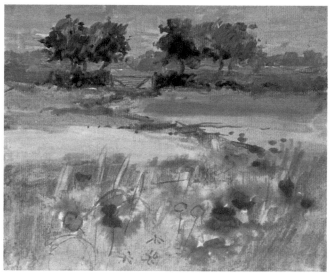

Stage 3

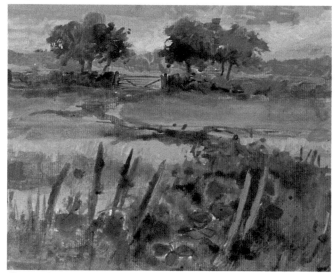

Stage 4

Poppy field: demonstration

Size:35.5 cm × 28.5 cm (14 in × 11¼ in)
Paper: fine grain oil-painting paper, prepared board or watercolour paper, 300 gsm (140 lb)
Brushes: nos. 4 and 6 hog-hair brushes, no. 4 ox-hair brush, no. 1 rigger brush
Colours: cadmium red, yellow ochre, cadmium yellow, olive green, ultramarine blue, white
Other materials used: acrylic gel, rag

I was attracted to this beautiful field of poppies while holidaying in Cornwall. The brilliant colour and striking contrast of red petals against rich dark centres make poppies one of the most popular subjects for artists to paint. Before starting on your piece, you need to spend some time becoming acquainted with the poppy's complex shape and design. Paint, however thickly applied, cannot cover up a bad drawing – rather it has a habit of accentuating it! Try to keep to a limited

palette, as I have. Five or six colours will give your painting harmony and clarity.

In any painting, when arranging the composition, I bear in mind that important details should have a sympathetic connection and an underlying rhythm to guide the viewer's eye gently through the picture. Often this concept can be based on the cradling effect of the letter 'C' or the leading effect of 'Z' or 'S'. I have based this composition on the letter 'Z' – look at the way the natural path carries your eye through the foreground of poppy flowers and then continues towards the gateway.

Stage 1

Using a rigger brush and watered down ultramarine, I quickly draw in the main features of the picture.

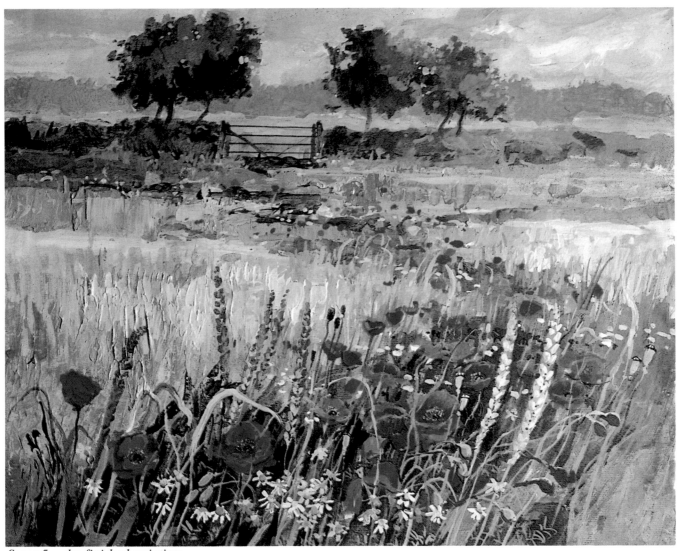

Stage 5 – the finished painting

Stage 2

I cover the entire picture, except for the poppy heads, with diluted yellow ochre, which is applied with a rag. I paint in the sky using a mixture of ultramarine and white. The distant trees and hedges are a mixture of olive green, yellow and blue, allowing glimpses of the ochre to shine through in places. A darker area of yellow ochre is applied to the top right of the field.

Stage 3

While the foreground is still wet (you may have to remoisten this) blend cadmium red poppy heads into the surrounding area. Still keeping the painting thin and loose, using a mixture of blue and white, I paint in the distant trees. Pale green areas are added to the field using cadmium yellow and blue and a little white, and I build up the gate at the same time. With a wash of olive green, I zig-zag the natural pattern down towards the flowers.

Stage 4

I darken the foreground, around the poppy heads, to give a feeling of depth and mystery. With the areas of dark and light now clear, I begin to paint more thickly, applying lighter colour to the left-hand side of the painting, light against dark on the right-hand side. I place in the corn heads, dark colours against light, and light against dark.

Stage 5 – the finished painting

At this stage, I refer back to my sketchbook for more details of the poppies, corn, daisy heads and foliage. These I paint in thickly using a flat-headed hog-hair brush, adding any details with my rigger brush. Finally, I mix acrylic gel with the middle distant colours (cadmium yellow and a little olive green) and apply the paint in bands of colour.

Riverside

Water is a difficult but rewarding subject, (see also Ray Campbell Smith's chapter 'Waterscapes' on pages 38–57.) It is a rich source of inspiration for the artist, adding extra dimensions to a painting, whether it is the perfect mirror images of still water or the softer distorted reflections of ripples and waves.

Movement disturbs quiet reflections, breaking them up into interesting patterns that zig-zag to form bands, circles and ovals. When light catches these forms beautiful effects are created. The glimmering blue of the sky gives life to dark shadowy areas. Wind ruffled water reflects the sky overhead and is always lighter than smooth water, so lighter and darker areas in a painting can describe the nature of the water – a fast flowing stream or a calm lake for example.

Bands of horizontal light across the water's surface, as shown here, prevent the illusion of the river appearing to 'lift' at one side or the other. The emphasis in this painting is on using and blending a variety of contrasting brush strokes to produce an interesting mixture of tone and texture.

Watery burnt sienna is applied with a rag to the whole surface, then all the main features of the picture are drawn in with a rigger brush. I try to cover the whole picture as quickly as possible, working out first how early layers of colour will help later ones.

The sky of ultramarine is applied with a large brush, blending in burnt sienna and white to add a little warmth to the horizon. The distant woods, river and reflected details are blocked in next, using mixtures of greens, browns and blues. When producing reflections I always paint in the object above first, then immediately rough in the reflected image with a downward movement. This gives a feeling of depth. Do not use horizontal strokes, or the river will resemble a path and not deep water.

I paint in the trees in the middle distance using burnt sienna and yellow ochre, and the pathway in pinks and yellows to give warmth to the green foliage that is to be painted over the top. At the same time I develop the foreground water, blending the colours into the pink glow of the reflected sky.

It is always a good idea to introduce a figure, animal or bird into a painting and here I decide to include a small bending figure amongst the irises, showing a full reflection in the water. The background on the right of the river bank has to be dark enough to highlight the glowing yellow irises; it is wise to remember the saying – 'the darker the shadows, the brighter the sunlight'. The irises in the foreground have to be dark against the lighter water surface. It is always advisable to use tonal reversal in this way when there is an area showing the same kind of foliage or flowers in a painting. It helps prevent the picture from becoming too boring.

A smaller hog-hair brush is used to paint in the nearest tree and details of the far distance. The path in the foreground is completed with a palette knife using dabs of grey, yellow ochre and green. A splattering of olive green is added to give a rough pebbled effect. Finally, using a large brush, I drag dry white acrylic paint down over the picture from the distant horizon to the foreground, to give an illusion of light filtering down from the sky above.

This detail of the painting opposite shows an interesting mixture of tone and texture. A variety of different brush strokes are used to produce this effect.

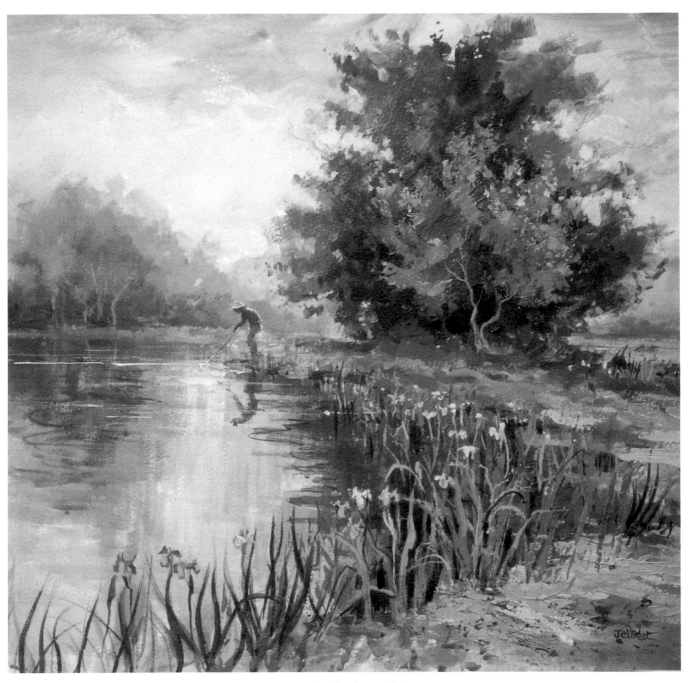

I draw in all the main features of the picture with a rigger brush after applying watery burnt sienna to the whole surface with a rag. I then start building up the colours, working out first how early layers of colour will help later ones.

The old gate

This painting includes many of the techniques illustrated on previous pages. If you have already tried these techniques out you will have no difficulty creating a similar picture for yourself. The photograph and sketch inspired me to paint this picture. Many ideas can be developed by superimposing objects, or by incorporating two or more individual sketches into one picture.

The gate is a wash applied briskly in green, burnt sienna and blue; these colours vary in tone depending on whether the gate is in sunshine or shade. The quick action of the acrylic wash traps small air bubbles, giving a lovely texture to the wood. The darker grain is painted in with a rigger brush and a mixture of crimson and green.

The background is divided into three distinctive areas; the first area is at the top right of the picture. A white-washed wall is painted boldly using a palette knife, with a touch of yellow ochre and white; acrylic gel is added to give the appearance of rough textured stonework.

At the top left of the picture, the foliage is created using a watery wash of greens and yellow ochre against a background of burnt sienna; the colours blend together to form an illusion of massed leaves. A little blue is added to suggest the deep shadowed area.

The stone gatepost on the left is painted in, using crimson, yellow ochre and green, and allowed to dry. Light grey (blue, white and burnt sienna) is scumbled over the surface, allowing the darker colour to show through. With an old toothbrush, I splatter a mixture of olive green and burnt sienna over the gatepost, creating the effect of a roughened surface.

I use a delicate watercolour technique on the dog roses, which is a direct contrast in colour and tone to the rough background. First I draw around the shape of the flowers, and some of the leaves and thorns, with masking fluid; this prevents the diluted acrylics from running and blending with other colours. I apply the watered down crimson to the flower heads and a mixture of diluted greens to the stems and leaves. When the paint is dry, I gently pull the masking fluid off, and add detail to the flower heads using crimson, yellow ochre and white.

Finally, the foliage between the wooden posts is painted in with thicker acrylics using a mixture of greens, and the lighter leaves of the dog roses are defined with a palette knife.

Both the pencil sketch of dog roses and the photograph below have been used to produce the painting on the opposite page.

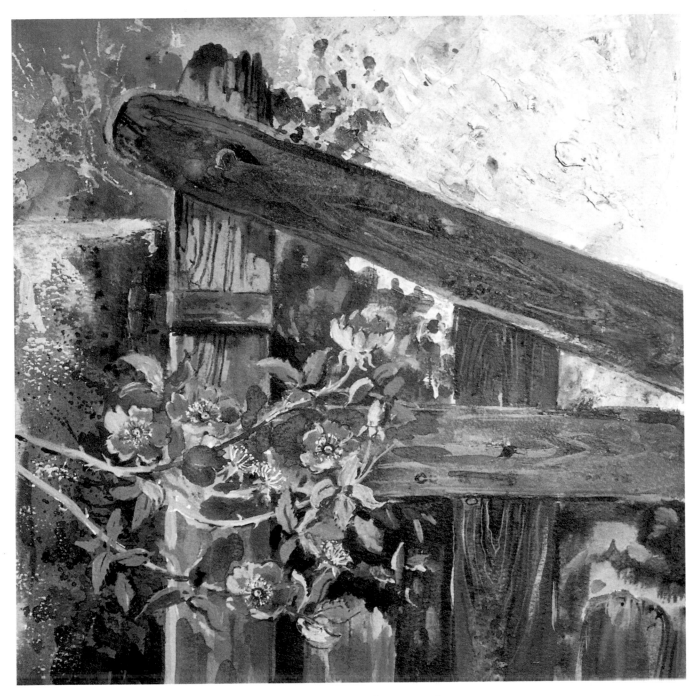

The whitewashed wall at the top right of the picture is boldly textured using a palette knife with a touch of yellow ochre and white; acrylic gel is added to give the appearance of roughened stonework.

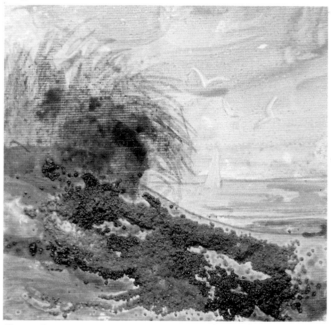

Stage 1

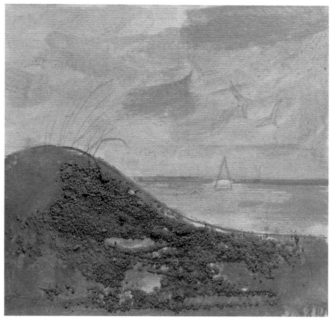

Stage 2

Stage 3

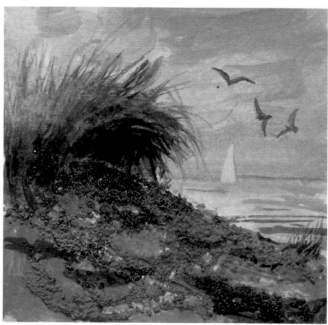

Stage 4

Sand dunes and seagulls

Size: 29 cm sq (11½ in sq)
Paper: fine grain oil-painting paper, 300 gsm (140 lb)
Brushes: 13 mm (½ in) flat hog-hair, no. 6 ox-hair brush, no. 1 rigger brush
Colours: ultramarine blue, yellow ochre, white, Van-dyke brown, burnt sienna
Other materials used: glue, grit, sand

I find sand dunes an inviting subject to paint as there is a wealth of texture to be explored. I have carefully composed the picture so it maintains a balanced 'rhythm' and is pleasing to the eye. The still, distant band of sea with its single sail, seagulls circling in the sky and a few footprints dimpling the sand, all add interest to the painting, giving me an opportunity to experiment with texture and colour.

Stage 1

Using a rigger brush and watered down ultramarine, I draw in all the important features. I spread glue over the foreground area where I want to show texture, and sprinkle sand and grit on to the surface. it is then allowed to dry.

Stage 2

A wash of ultramarine, white and a little burnt sienna is

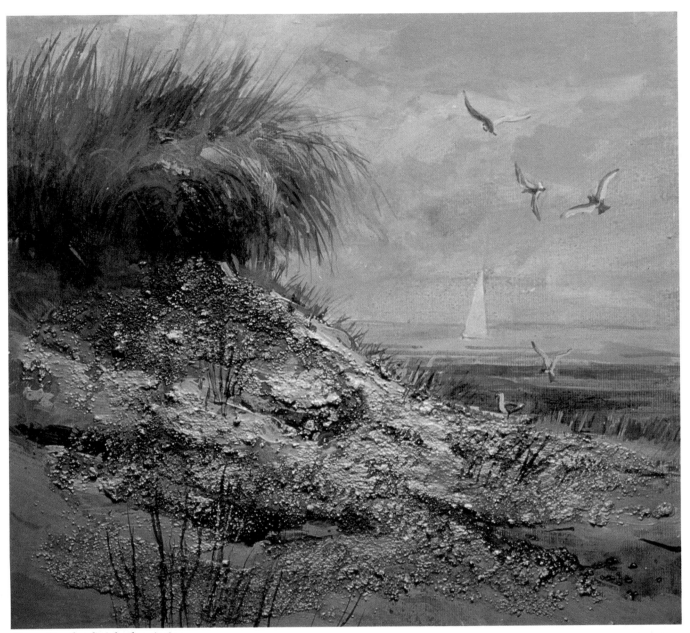

Stage 5 – the finished painting

painted into the sea and sky and yellow ochre is washed liberally over the sand dunes. I will allow this yellow ochre underwash to show through in places as I build up the texture and layers of paint.

Stage 3

Where the grass grows profusely on top of the dune, I paint it in with an ox-hair brush, using Vandyke brown and ultramarine. The footprints are added in the same colour. This stage is completed by painting the distant sail and seagulls white.

Stage 4

More detail is added to the grasses and footprints, and I darken the seagulls and waves on the shoreline using undiluted ultramarine.

Stage 5 – the finished painting

To create the right colour for the darker shadows I mix ultramarine, Vandyke brown and burnt sienna, painting this into the footprints and dune area below the grass. I mix plenty of yellow ochre with white and drag it over the textured area of sand; the paint is attracted to the raised rough surface and the whole foreground area seems to sparkle like sunlight on sand. The yellow ochre underwash should still be showing through in places.

The following details are then added with a rigger brush; light strands within the dense grasses, and darker tufted grasses in the foreground. I paint in seagulls on the shore and add details to the birds overhead.

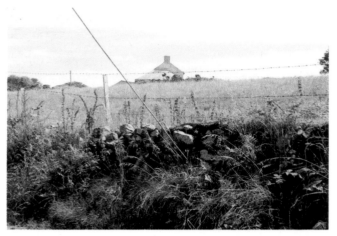

A rough stone wall and isolated cottage make an ideal subject for the painting opposite.

Cornish stone wall

When painting a complicated subject, careful consideration should be given to the composition of the picture. A well-composed painting should have a pleasing balance; complex areas should blend with areas of tranquility, otherwise the whole picture will appear too busy and fussy. Here is a perfect example of balance.

The complexity of stones and grasses, crowned by fence posts and brambles is offset by a subdued sky and an uncluttered distant field. I particularly like the roughened stones which peep out and tumble down the hedge. The contrast between the greenery on the wall, the cow-parsley and feathery grass is a textural delight!

The picture is based on the photograph and sketch on this page and my palette is limited to a few colours – olive green, burnt sienna, white, ultramarine and yellow ochre. I mix these to achieve varying shades and tones of other colours.

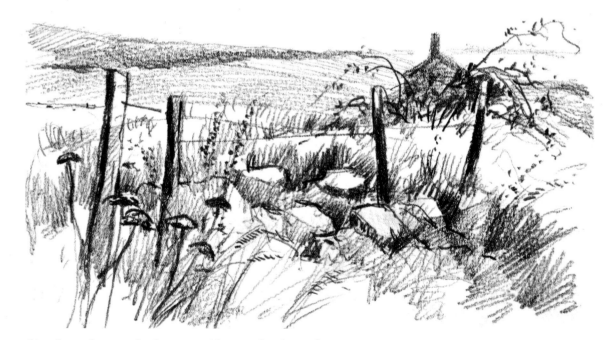

When working from photographs the composition can be changed to create a more pleasing balance. In this sketch taken from the photograph above, I have altered the composition slightly and added a background of hills and distant fields.

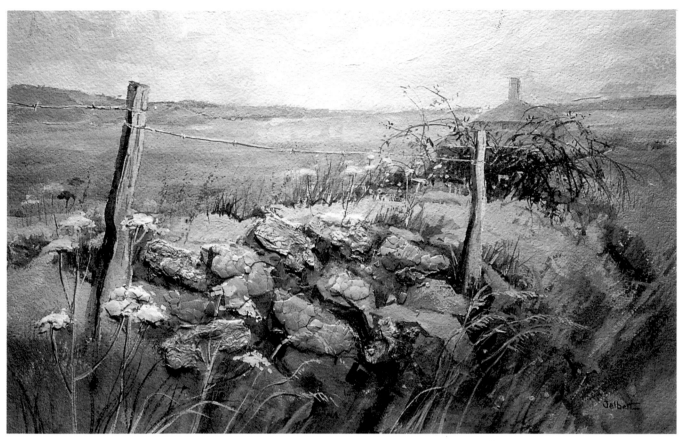

Egg shells are used to emulate the rough texture of an old stone wall. The shells are broken into small pieces and pressed into glue over the proposed textured area before any paint is applied.

After deciding that egg shells will beautifully emulate a stone-like texture. I draw in details of the main composition, then brush a thick coating of glue over the proposed textured area. I press broken pieces of egg shell well into the glue and allow them to dry. I then lay a good covering of yellow ochre over the whole picture, washing burnt sienna over the stone areas to give them a warmth that will show through later layers of paint.

I paint in the sky, distant hills and the field in the middle distance with a mixture of white, blue and green. I use two greys – a blue-grey (burnt sienna and ultramarine), and a green-grey (burnt sienna, ultramarine and a touch of olive green), in the picture. These colours are used on the stones, fence post and silhouette of the Cornish cottage. I add touches of burnt sienna to indicate sorrell plants, giving points of vibrancy to the green grasses. Finally, the cow-parsley and the wispy grasses are painted in with a rigger brush.

Detail of finished painting.

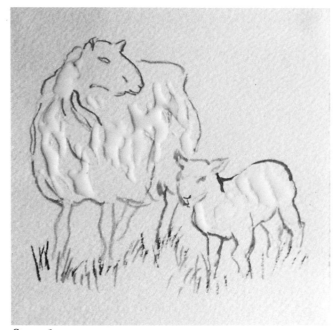

Stage 1

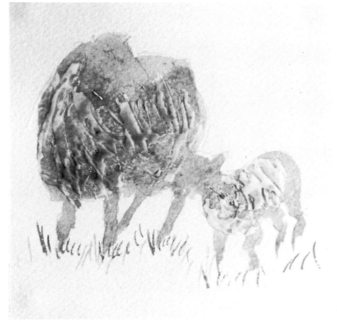

Stage 2

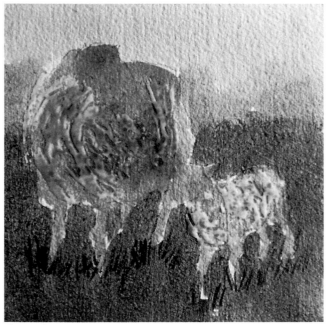

Stage 3

Stage 4

Sheep

Size: 31.5 cm × 26.5 cm (12 in × 10½ in)
Paper: watercolour paper, 300 gsm (140 lb)
Brushes: no. 6 ox-hair, no. 1 rigger
Colours: ultramarine blue, burnt sienna, olive green, cadmium yellow, white
Other materials used: glue

The difficulty with sketching and painting animals is that you have to find one that will stand still long enough for you to do even an initial sketch. I have many half completed studies in my sketchbook because the animal became bored and moved away! Here photographs are extremely useful and I also find toy farm animals invaluable in helping me surmount this problem. I have kept many model animals from my children's younger days, and they are of great use both to me and my students. They can be viewed from any angle – a whole flock of sheep can be created by using just one tiny model in varying positions.

The main problem is achieving the correct size in relation to the rest of your picture. You will need to

Stage 5 – the finished painting

rough out the whole scene before you start, adjusting sizes in the sketch until the composition and scale of the whole picture looks correct. Here I apply lines and splashes of thick glue to the initial drawing of the sheep. It seems to perfectly illustrate the rough and woolly texture of fleece.

Stage 1
Using diluted ultramarine, I accurately draw in the sheep and lamb, before dribbling the glue over the fleece. I then allow it to dry.

Stage 2
I apply a wash of burnt sienna over the dried glue, letting it run into the surface patterns.

Stage 3
I introduce the light sky mixing a wash of ultramarine and green, and add a little more blue to capture the distant hills. I add a touch of burnt sienna and green, then paint around the sheep and lamb. Using darker green, I paint in details of grass around their feet.

Stage 4
I darken the shadows and run a deeper wash (burnt sienna and olive green) over the fleece and faces of the sheep. Cadmium yellow dots represent buttercups in the grass.

Stage 5 – the finished painting
I define the grasses and details of the fleece and faces of the sheep using a rigger brush and yellow ochre and white. With the same colours I use a dry hog-hair brush and skim it over the surface of the fleece across the backs of the sheep, to give a feeling of light and depth.

Finally, shadows are added beneath the animals bodies, and dark streaks are painted into their coats.

Miniatures BY CYRIL TURNER

Reed cutter's hut, Norfolk Broads.

Introduction

People have been painting miniatures for thousands of years. Throughout history tiny pictures have been created either as decoration or to illustrate religious themes. These miniatures are as popular today as they ever were. They are worked on a very reduced scale. The smaller they are, usually the higher the standards have to be to achieve such fineness of detail.

Whether you are an experienced miniature painter, or a complete beginner, the first thing you have to think about is the selection of your subject and the size and shape of your final painting. Just as for a larger painting the picture has to be well balanced and complete, and not just comprised of details extracted from a larger composition. Scale is the first consideration; composition and balance are important, and to a lesser degree overall size has to be considered.

There are many subjects which can be recreated in miniature – landscapes, still life, floral studies, buildings, portraits, animals, etc. I do not cover all the subjects in this chapter, but attempt to help you create a miniature painting using a variety of stage by stage demonstrations. By following these instructions, and studying the pictures, you will soon be able to confidently choose your own subjects and to capture them in miniature.

As with larger paintings, it is important to consider space as a part of your miniature. Subjects such as still life, floral studies, portraits, etc., require sufficient space around them so they do not appear cramped. Leaving slightly more space than is necessary makes little difference and retains balance, whereas slightly insufficient space is most noticeable and destroys the harmony of the miniature.

Once I have chosen my subject, I always make a sketch of the same size and shape as my intended miniature and apply artistic licence to balance the composition. There may be a need to leave some items out completely, or I may have to alter or adjust their position to make a more pleasing composition. Quite often I have to insert depth or distance into the picture. When working on a miniature scale artistic licence is far more easy to apply and is more flexible in its use.

The following demonstrations and stage by stage paintings have been planned to help you build up confidence in miniature techniques. By using them as a guide and by practising, you will soon be able to choose and paint your own beautiful miniatures.

Materials

The materials required for general acrylic painting are discussed earlier in this book on pages 8 and 9. However, although the basic materials are the same, you will require more detailed information on which materials are specifically used for painting miniatures.

As mentioned previously a variety of surfaces can be used with acrylics. I use Bristol board, paper, card, wood, glass, board or vellum. If you are a beginner, mountcard or Saunders mould made HP paper on board will provide a good base. The miniaturist can cut down most of these larger surfaces to the size required. It is worthwhile taking time to experiment by applying a complete background to your chosen surface. If you like the result, then carry on.

Acrylics are versatile and quick drying, and are therefore an ideal medium for the miniaturist. I would recommend that you use a 'wet' palette, as acrylics dry so rapidly (see page 8). However, if you do not have one available, only put a small amount of each selected colour out, otherwise the paint will harden as it dries. A retarder can be added to the colours to slow down the drying process, if required.

I prefer to use a wide range of colours. I find that often a fine line of colour change is the best and easiest way to obtain some of the intricate detail in a miniature painting. As only small amounts of paint are used, your tubes will last for a long time.

Brushes should always be of good quality. I use a 1 cm (½ in) flat sable for backgrounds, areas of sky and water. For the main part of my painting, I use nylon brushes : nos. 0–1 flat and 000–1 round. Then for finishing off and fine detail, I use kolinsky sables nos. 00000–1 round; some of these brushes have a very fine point and some have a rounded point (spotting sables).

Various mediums are available for use with acrylics. I recommend that you use an 'acrylic flow improver'. I find by using this medium I can achieve a lovely even finish on my miniatures, which would be impossible otherwise. Gloss and matt mediums can be diluted and mixed with the paints. The colours either take on a glossy look, or their brightness can be reduced. I find the matt medium can be helpful on occasion.

I keep a sketchbook by my side for recording anything I find interesting, and always keep a few well-sharpened HB pencils available. Rubbers are not an essential part of my equipment, but if you do need to use one, make sure it is soft.

Although I do not work with a magnifying glass, you may find this a useful piece of equipment. Some magnifying glasses can be bought complete with attachments and a light. When working under a magnifying glass it is important to remember that you must always have the centre of the glass over the area of the picture you are working on, as the edges of the glass can distort the view a little. A viewfinder is another useful item. Different sizes and shapes of window can be cut out of a piece of card, to the same dimensions as your proposed painting, (oval, square or round, etc.). By holding the viewfinder not further than four inches away from you, and by looking through the aperture, you can work out and decide upon the composition of your painting.

I work on a drawing board and prefer to have it slightly angled. It is better to work in daylight if you can, but if you do have to work in artificial light, then cover your working surface with black card or fabric and place your miniature on top. The black background will prevent light from reflecting up into your eyes while you are working.

Framing

Once you have finished your miniature you will want to frame it. It is more appropriate for original fine art miniature paintings to be framed without a mount or matt. Therefore when selecting suitable shapes and sizes for the finished painting, you can take into account the selection of readily available stock sized frames:

Rectangular frames: 4.5 cm × 6 cm (1¾ in × 2⅜ in), 5 cm × 7 cm (2 in ×2¾ in), 6.7 cm × 8.6 cm (2⅝ in × 3⅜ in),
Oval frames: 5.5 cm × 4 cm (2⅛ in × 1½ in), 7 cm × 5 cm (2¾ in × 2 in)
Circular frames: 6 cm (2¼ in) diameter.

Techniques

Here I cover my methods of working, so you will be able to follow the stage by stage instructions in this chapter. By using these methods, and perhaps by eventually adopting your own as you progress, you will be able to choose subjects that appeal to you which can be captured in miniature.

I always work from initial sketches on my more complicated miniatures. When seeking inspiration for landscapes or outdoor scenes I often embark on sketching trips which can last up to a week. I easily get lost in my work for hours if I stumble across a suitable subject. When painting still life I often arrange studies. These arrangements do not always need sketches. However, it sometimes helps to make an outline sketch the same size as the intended painting.

The first thing I have to decide upon is the size and the shape of the painting. For a painting to be classed as a miniature it is becoming a more general practice now to reduce the image to less than a sixth of its actual size, (see the demonstration on page 120). This rule can be applied as a general guide when you are looking for a suitable subject.

When considering landscapes the size and shape is really determined by the content. If the view is panoramic, then I favour a longer, narrower format,

(see page 117). If the view is more 'enclosed', then I prefer a more upright format, (see page 114). If the subject is still life or flowers, circular, oval or straight-edged formats can be used. It is up to you to study your subject and decide on the best way to present it. Practise different formats and a few simple sketches in your sketchbook. The overall size of your painting should be limited in area to approximately two hundred and twenty five square centimetres (thirty six square inches), although this can vary depending on the individual miniaturist. The aim is to paint in the most diminutive scale which will automatically restrict the overall size. Ultimately, when viewing an original fine art miniature painting the actual overall size should contain three elements: depth (distance), light and space, and the whole work should present itself as complete, not bound by a frame.

If you are not happy with your subject, the painting can be improved by increasing either the distance, light or space within the picture. By doing this the working scale will automatically be reduced; often this enhances the miniature. Or apply a little artistic licence; move items around if the picture seems unbalanced. Leave them out or adjust them slightly. Work at the composition until you are pleased with the results.

When painting landscapes I always make notes to accompany my first 'master' sketch. Also, I draw any small details on a larger scale at the side of the first sketch, if I feel they will enhance the finished painting. When making sketches, although to your eye the pencil lines are black and white, try to imagine them in full colour. It is an interesting exercise and helps in the final analysis of the miniature. Colour notes are particularly helpful and I always add these to the master sketch.

Once I am happy with my master sketch, I draw out a simplified copy and split it up into areas as follows: 1 foreground; 2 middle ground; 3 middle distance; 4 far distance; 5 extreme distance. I use this sketch as reference throughout Stage 2 of the painting. Each area is worked on separately and it helps to bring a three dimensional effect to the finished miniature.

In the first stage, using both sketches as reference, I work on the background colours using a 1 cm (½ in) flat sable and a size 0 nylon brush, applying the paint with quick even strokes. The brush should remain moist at all times and should be cleaned at frequent intervals. If you choose to use a watercolour palette, (see page 10), the brush may frequently be gently rolled on the tissue under the water. This will keep it clean and undamaged. The whole working surface on to which a miniature is painted should be completely covered to form the background, and not left partly worked.

It is important to keep the base clean and dust-free throughout all stages of working. During the drying stages (there are three in each demonstration), I place the miniature in a dust-proof container and allow it to dry thoroughly before going on to the next stage. This is usually approximately three hours. But it is better if it is left to dry overnight.

During Stage 2, I explain how to build up the colours in all areas of the miniature using a variety of smaller sized brushes, (see 'Materials' on page 109). Rather than being specific in my instructions regarding which brushes I use in Stages 2 and 3, I feel it is better for you to practise using the various sizes on a separate piece of paper before applying the paint. Use small brush strokes, building up layers of colour with each brush, until you feel confident enough to attempt the next stages of your miniature.

Occasionally I use a stippling technique. For this I use one of my old paintbrushes, and I cut off half the hairs so the tip is 'blunt'. I then cover the area I am working on with one colour, and using a slightly darker shade I apply small amounts of the paint over the base colour, allowing it to peep through in places. This technique is a little difficult with acrylics because of its quick-drying qualities, but a retarding agent can be used to slow down the drying process.

In Stage 3 I demonstrate how to add the final colours and tiny details to the painting, which will enhance the miniature.

Hearty Gate Somerset: demonstration

Size: 8 cm × 7 cm (3¼ in × 2¾ in)
Base: Saunders mould-made HP paper on board

I chose this scene because it shows an area which is below the viewpoint of the miniaturist, i.e. the area below the top of the bridge. The painting gives two alternate view areas; one is centred as the light area of water under and below the bridge arch, and the other is the distance – a point between the buildings and the left edge of the miniature. The three-dimensional effect here is outstanding, as there is a shift of eye focus when changing from one view area to the other. The positioning of the top line of the bridge helps considerably to achieve this, as does the use of an upright format for this miniature.

I draw my master sketch, the same size as the intended miniature, and then make a simple copy and mark in the areas 1–5.

Stage 1 (*see overleaf*)

For the sky I mix the following colours: two shades of light blue using titanium white and ultramarine, a very light yellow shade using titanium white and a touch of azo yellow light; a peach shade using titanium white with touches of yellow ochre and indo orange red. With a 1 cm (½ in) flat sable I paint in the sky using quick even continuous strokes across the top of the base. I place the darkest of the blue shades by a stroke across the top, and directly below this I make two strokes of the lighter blue. Directly below these I place two strokes of the peach shade. I then place a stroke of the very light yellow shade over the lower portion of the blue and the upper portion of the peach shade, thus blending the two colours together.

The colours for the clouds are mixed from titanium white, Payne's grey and ivory black. Using a size 0 or 1 round nylon brush I roughly fill in the clouds and paint

Master sketch

Area sketch

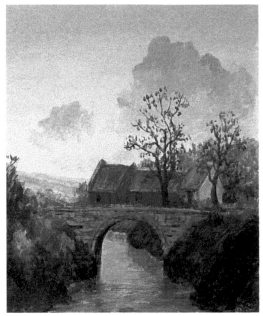

Stage 1

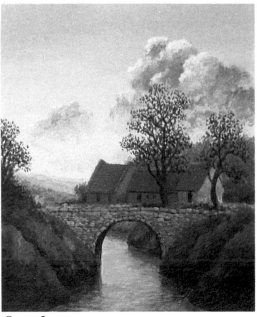

Stage 2

in the blue line of the extreme distance running from the left edge of the miniature to the buildings.

Using a mid-grey, I draw in the outlines of the buildings, the bridge and both banks of the stream, taking care when placing the building which stands above the skyline.

I mix a number of green shades from light to dark using yellow ochre, cadmium yellow medium, light green oxide, chromium oxide green, olive green, Hookers green, raw umber and ivory black.

Now I work on the far distance and paint in the light greens. I use light, mid and dark greens on the foreground banks of the stream and mid-greens on the middle distance trees and foliage behind and at the sides of the buildings.

I mix the colours for the buildings and bridge using indo orange red, cadmium orange, raw umber, Payne's grey, red iron oxide, titanium white and ivory black.

I roughly fill in the stone and brick tiled buildings and paint in the stone and brick bridge. I mix colours for the water using titanium white, ultramarine, chromium oxide green and raw umber. I place the light blue area under and below the arch and fill in the greenish blue areas of bank reflection. I paint in the remaining areas using mid-yellows and mid and dark greens. Finally I roughly place the two trees in the middle ground, taking care where they extend above the skyline. The painting is now left to dry thoroughly.

Stage 2

Throughout this stage I work each area separately, using the area sketch as a guide (see page 111).

Extreme distance (5): I mix the colours for the clouds in the extreme and far distance using titanium white, Payne's grey, ultramarine, yellow ochre and cadmium red. I blend in the clouds just above the skyline so that they are hardly visible and make the skyline and the blue area below softer by applying a very light blue. I shape up the clouds exactly and blend in the colours, painting a line of off white on the top edges, which gives a feeling of movement.

Far distance (4): I fill in the small area between the left bank and the buildings with mixes of colour made from titanium white, light oxide green, and phthalo green. I place a very light green stroke at the top, and paint in a hedgerow running down from the bush on the left, towards the buildings.

Middle distance (3): I mix a number of green and brown shades from raw sienna, yellow ochre, olive green, sap green, permanent green, azo yellow light, cadmium yellow medium, Hookers green and Mars black. I then mix colours for the buildings and bridge using cadmium orange, red iron oxide, cadmium red medium, Payne's grey, raw umber, titanium white, dioxazine purple and Mars black.

I shape up the trees behind and to the right of the

buildings exactly and paint them in with greens and browns. I paint in the bush and hedgerow to the left of the buildings more clearly using a dark green and shape up the buildings exactly. Next I paint in the roofs using light red rust on the left, a reddish brown in the centre and a red rust on the right. On the centre and left buildings I paint in the brickwork and I also paint in the walls of the right building using a light grey, placing shadows and lining and painting in windows and doors.

Middle ground (2): I paint in the narrow strip of bank across the top of the bridge with light greens and yellows and make the bank which can be seen through the bridge arch more definite using light and mid-greens. I line in exactly the two trees on the left and add some foliage using dark green.

Foreground (1): I line in the bridge exactly, showing the stonework, and paint it in using a variety of greys. I then paint in the bank on the left more precisely using light to very dark greens. I add more detail to the water painting it in more exactly, giving dark green reflections of the banks, and I place the reflection of the bridge arch exactly. The whole water area is given a brushing with a light blue wash to form the surface of the water. These strokes are all made to run parallel with the bottom of the picture so that the water appears level. The miniature is now left to dry thoroughly.

Stage 3 – the finished painting

With a mixture made from titanium white and a touch of yellow ochre, I add strength to the main cloud edges. Mixes from Payne's grey, titanium white and ultramarine, are used in final minor adjustments to the body of the main cloud to give it the appearance of movement behind the trees.

I mix colours for the building walls and bridge from cadmium orange, cadmium red medium, red iron oxide, raw umber, dioxazine purple, titanium white, yellow ochre and ivory black.

I slightly adjust the brickwork of the buildings in the centre and on the left and square up the doors and windows exactly. I adjust the walls of the building on the right and square them up exactly.

I work the bridge, making full adjustments to the detail on the stonework, paying particular attention to the areas around the arch and along the top edge. Then I paint in the underside of the arch exactly.

I mix a variety of greens from light to very dark using chromium oxide green, Hookers green, olive green, sap green, yellow ochre, azo yellow light, cadmium yellow medium, raw umber, ivory black and Mars black.

The line of grass between the buildings and bridge needs softening especially the area to the left of the

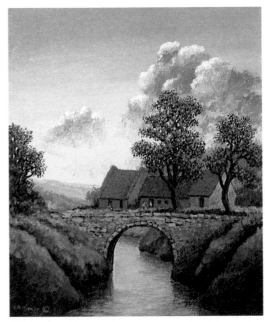

Stage 3 – the finished painting

picture. I work the two main trees and paint in the trunks and main branches more clearly, lining them up exactly and indicating the areas of shadow. I extend the branches slightly and add foliage, shaping it up exactly.

I add more foliage to the bush on the left bank, shaping it up exactly and make the bank through the bridge arch slightly lighter towards the top of the arch. I also make the left bank lighter at the top and shape it up exactly. I blend a lighter green into the right bank, and shape it up exactly. Finally I paint in the three figures; the one on the left is on a scooter, the central figure has a barrow and is talking to the third figure in the doorway.

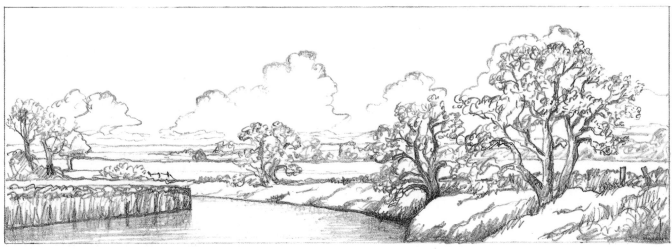

Master sketch

Stokesby, Norfolk: demonstration

Size: 6.5 cm × 18 cm (2½ in × 7 in)
Base: Vellum

Views with a low horizon are especially suited to miniature painting. Here I have chosen a peaceful river scene as my subject, using a little artistic licence to maintain picture balance and to achieve a good composition.

First I draw my master sketch the same size as my intended miniature. Then I make a simple sketch indicating the areas 1–5.

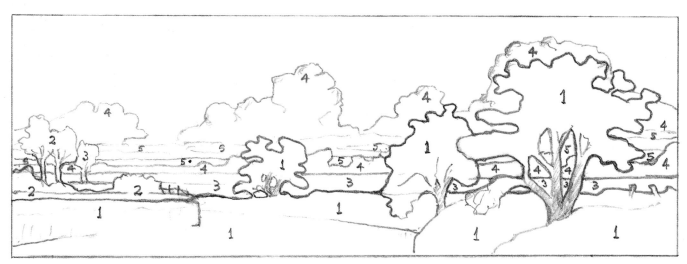

Area sketch

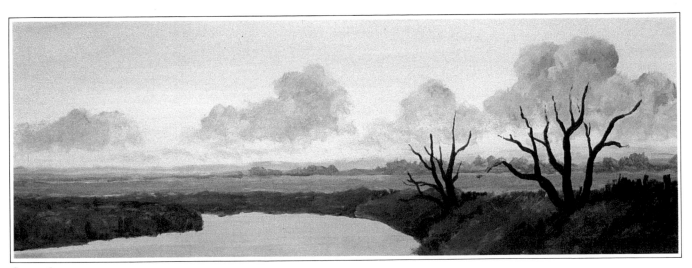

Stage 1

Stage 1

I use two shades of light blue for the sky, mixing them from titanium white, ultramarine and cobalt blue, the lighter shade being almost white. I also mix a very pale peach shade using titanium white, with touches of yellow ochre and cadmium orange. With quick even continuous strokes across the vellum, I place the darkest of the blue shades along the top, using a 1 cm (½ in) flat sable. Immediately below, but slightly overlapping, I paint a stroke of the lighter blue, and immediately below this, again overlapping, a stroke of the pale peach. The shades will automatically blend into each other as the paint is applied.

With a size 0 nylon flat or round brush, I place in the main clouds using mixtures of ultramarine, Payne's grey, ivory black and titanium white.

I then mix a darker blue for the area of extreme distance below the skyline using titanium white and ultramarine, and place it across the picture.

Using titanium white, light green oxide, permanent green, azo yellow light and cadmium yellow light, I mix a number of mid greens and paint in the area of far distance, placing two narrow lines of the lightest greens directly below the blue of the extreme distance.

Now I paint in the line of trees running two thirds of the way across the picture from the right edge of the painting, using the mid-greens I have just mixed. Immediately below the tree's base line I fill in the area of middle distance and middle ground using light greens.

I use mixtures of cadmium yellow medium, yellow ochre, chromium oxide green, sap green, olive green and Mars black on the river banks and place the tree trunks and main branches on the right bank, using a mixture of Mars black and sap green.

Now I work on the river, using mixtures of titanium white with touches of ultramarine and olive green. I make all the brush strokes parallel with the bottom of the painting. This ensures that the water surface will appear level. I now leave the painting to dry thoroughly before the next stage.

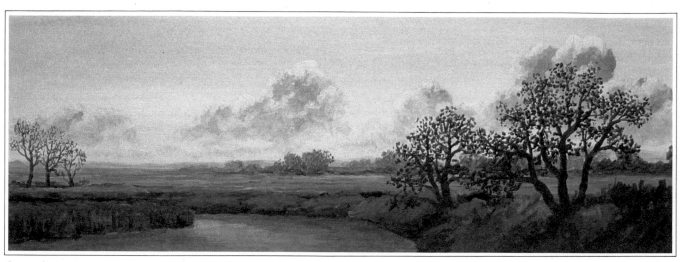

Stage 2

Stage 2

Throughout this stage I work each area separately using the area sketch on page 114 as reference.

Extreme distance (5): I mix up a number of colours using titanium white, ultramarine, Payne's grey, ivory black, yellow ochre and cadmium orange, for the clouds and the extreme distance. Referring to the area sketch, I blend in the clouds just above the skyline so they are just visible, softening the edges into the sky, and work on the skyline making it slightly lighter in places. I then blend in the blue below the skyline using a very light blue.

Far distance (4): Using titanium white, light green oxide, azo yellow light, cadmium yellow light, permanent green, Payne's grey and olive green, I mix up several light to mid-greens. I place two narrow lines of light green below the light blue of the extreme distance and paint in, in more detail, the line of trees stretching two thirds of the way across the picture. Using mainly mid-greys I then shape up the clouds exactly and blend them in, painting in light off-white edges so they appear to float across the sky.

Middle distance (3): I fill in the area below the tree base line across the picture using light greens, strengthening them towards the middle ground. Then, using light and mid-greens, I carefully paint in the far tree on the left of the picture, paying attention to the branches and foliage above the skyline. These are placed with delicate brush strokes – as any mistakes are clearly visible against the light background.

Middle ground (2): I use mid-greens for this area, blending in the colours as I work, and paint in the two trees on the extreme left of the picture, taking care when placing branches and foliage above the skyline. I place a strip of light green below the three trees and make up a mixture using chromium oxide green, cadmium yellow medium and raw sienna to complete the middle ground area down to the river bank.

Foreground (1): I mix a range of greens and browns, light to very dark, using cadmium yellow medium, yellow ochre, burnt sienna, raw umber, chromium oxide green, sap green, olive green and Mars black. Various greens and a rust brown are used to add detail to the reed bank on the left and I shape up the right river bank with the addition of light and mid-greens and browns. I extend the branches of the two trees on the bank slightly, and add mid and dark green foliage. The area of water is given a greenish grey base, which is darker near the banks becoming lighter towards the centre. I make all the brush strokes parallel with the bottom of the picture so the water appears level. The painting is now left to dry completely.

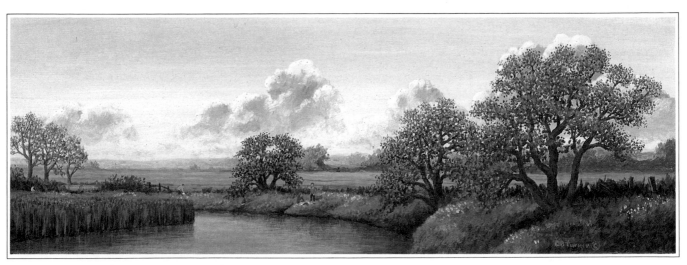

Stage 3 – the finished painting

Stage 3

I mix up two colours for the clouds, using titanium white with touches of yellow ochre and indo orange red, and titanium white, dioxazine purple, Payne's grey and ultramarine. I add the light edges and blend in the body of the clouds using the light purple shade I have already mixed. The clouds appear to move across the sky as I develop their form. I soften the skyline on the left with a pale blue and strengthen the blue distance through the trees on the right.

Next I mix a variety of light to very dark greens and browns using cadmium yellow medium, azo yellow medium, cadmium orange, red iron oxide, raw sienna, yellow ochre, permanent green, Hookers green, olive green, Mars black, raw umber, burnt umber and ivory black.

I fill in the line of trees stretching two thirds across the painting from their right in more detail and place the shadows. The trunks and main branches of the three trees on the left need more work so I line them in exactly, extending their branches slightly. Using mid and light green foliage I shape them up exactly. I add the two clumps of brambles and the fence on the river bank, on the left of the picture using mid and dark greens, and paint in the small tree on the river bank. Using dark browns I line the trunks and main branches and add the foliage using light to dark greens.

I now fill in the grasses and flowers that grow along the top of the river bank from the right edge almost to the fence, using dark greens and reddish browns. Next I paint in the posts on the bank at the extreme right of the picture, indicating the areas of light and shadow. Using dark and mid-greens I draw in the trunks and main branches of the two trees on the right river bank, extending the branches slightly. I add light to dark green foliage to the trees, shaping them up exactly.

A little more work is needed on the river bank, so I brighten it up using light greens and place patches of buttercups along the entire bank. Then I line in the reed bank exactly using light to very dark greens and browns.

I paint in the figure fishing at the extreme left of the picture and the angler in blue near the far fence. Next, I add the two anglers just to the right of the small tree.

Finally I work the water area, painting in the reflections of the bank and anglers on the right, and the reflections of the reeds on the left. I blend in the colours from green to light blue towards the centre of the river. As before, all brush strokes made in the water area should run parallel with the bottom of the picture to achieve a level finish.

Wild roses: demonstration

Size: 6 cm diameter (2¼ in diameter)
Base: Bristol board (thick)

This demonstration is painted directly on to a prepared base from an arranged study, and therefore I would not normally use a sketch. However one has been made here to assist in scale reduction. Also it helps to achieve a balanced composition if you plan out your sketch beforehand.

Balancing a circular format is ʌt achieved by first drawing in the area around the eʒe of the circle, and then positioning the remaining flowers and buds, without the foliage, in the central area.

I have used Bristol board as a base here because it is ideal for the sharp clean cut fine lines required on small formats. Also, I have applied the one sixth rule and reduced the roses to one sixth of their original size.

Stage 1

Stage 2

Stage 1

Before starting, I check that the base is absolutely clear and free from dust. Then I completely cover it with a mid-blue background mixed from cobalt blue, Payne's grey, ultramarine and titanium white. This background is applied with a 1 cm (½ in) flat sable, using quick even continuous strokes across the base, which produces an overall even finish. I then place the painting in a dust-proof container and allow it to dry thoroughly.

Using a mid-grey and a size 00 kolinsky sable round with a very fine point, I carefully draw in all the outlines. Changing to a size 00 nylon round brush, I fill in the roses and flower buds using a mixture of titanium white with touches of yellow ochre and quinacridone red. Then I paint in the leaves, buds and stems using sap green, ensuring that all the drawn outlines are covered. The miniature is now left to dry.

Stage 3 – the finished painting

Stage 2

I mix three shades: a peach pink, a very light pink and an almost white pink from titanium white, naphthol crimson, quinacridone violet and yellow ochre. Using a size 00 nylon round brush, I work the roses, blending in these three shades, petal by petal, with brush strokes made towards the centre. I mix three shades-light, mid and dark from yellow ochre, raw sienna, red iron oxide and Mars black, for the centres of the flowers. I blend these in carefully.

I mix a variety of green shades from light to dark from sap green, chromium oxide green, permanent green, olive green, azo yellow medium, yellow ochre and Mars black. Then, using a size 00 nylon round brush, I work the leaves indicating areas of light and shadow. I add the main central veins and fill the centre of the painting with interwoven foliage. The miniature is now allowed to dry thoroughly.

Stage 3 – the finished painting

I mix three shades of peach, pale pink and very pale peach for the flowers from titanium white, quinacridone violet, naphthol crimson and yellow ochre. Using a size 00 kolinsky sable round brush, I paint in the flowers exactly. I work on each individual petal blending them in from peach through to pale pink, and very pale peach towards the centres. With mixes made from yellow ochre, raw sienna, red iron oxide and Mars black and using a size 000 kolinsky sable round brush, I paint in the centres of the roses exactly. Changing to a size 0000 kolinsky sable round brush with a very fine point, I paint in the anthers as a series of placed fine lines with specks around the centres.

I mix a variety of green shades from very light to very dark, using sap green, permanent green, olive green, azo yellow medium, cadmium yellow light, yellow ochre and ivory black. Then, using a size 000 kolinsky sable round brush, I paint the foliage in and shape it up exactly. Working on each individual leaf, I place all the veins and the serrated edges. I paint in the stems exactly and strengthen shadows and highlights. Finally I carry out an overall check and make any slight adjustments or alterations to complete the miniature.

Anemones

Size: 6 cm × 4.5 cm (2¼ in × 1¾ in)
Base: Bristol board (thick)

The subject matter for this miniature is arranged on a glass table top and painted directly on to the base, without referring to a sketch. I use the one sixth rule, reducing the anemones down to one sixth of their original size.

First I cover the background, using the same colour and techniques as used for the demonstration opposite (see Stage 1). Then I outline and line in the flowers, buds, stems and the foliage adjacent to the flowers using quinacridone red and olive green and a size 000 round nylon brush.

Using a mixture of quinacridone red and naphthol crimson I work on the flowers and buds, building up the colours and highlighting the centres and edges of the petals. I fill in the flower centres using a dark brown.

Finally I work on the remaining foliage, painting it in and working from the centre towards the edges of the arranged study, using a variety of light, mid and dark greens, mixed from sap green, olive green, permanent green, cadmium yellow medium, ozo yellow light, yellow ochre and ivory black.

Antiques with tulips, fruit and miniature landscape: demonstration

Size: 11 cm × 8 cm (4¼ in × 3¼ in)
Base: Saunders HP paper on board

With still life studies it is not normally necessary to make a sketch of the subject matter, as these miniatures can be painted straight on to a plain base from arranged studies. However, it may be helpful to make an outline sketch the same size as the intended painting so the overall uniform scale, composition and picture balance can be worked out beforehand.

As all original fine art miniatures are painted on a very reduced scale, the one sixth rule is applied as a

Outline sketch

general guide. At first you may find this difficult to judge. An easy way to achieve it is to measure one of the items you are going to paint. For example, in this study the antique tea caddy measures 11.5 cm (4½ in) across, therefore it should measure less than 2 cm (3¼ in) across in the miniature. By drawing the tea caddy in first to set the scale, all the other items can be drawn in relative to it. This will result in a uniform scale of reduction throughout.

I arrange the items in the still life group, paying particular attention to the colours which can be a valuable aid when working on the perspective in a picture. The light grey background gives the best three dimensional colour combination. The pale gold ochre coloured frame of the miniature painting sets it in the background against the light grey of the wall. The blue of the vase and the brown of the tea caddy bring the two items forward in the picture. The same applies to the green and red of the tulips. The orange contrasts well with the brown tea caddy and the red of the apples stands out against the vase and the tea caddy. The bright colours of the fruit make them appear nearer.

Before starting, I position a light to give good contrasts of highlights and shadows. These highlights may be drawn in on the outline sketch for future reference.

Stage 1

I check the base material to ensure it is absolutely clean and free from dust, before covering it with a light grey mixed from titanium white and very small amounts of ivory black, cobalt blue and dioxazine purple. I apply it with a 1 cm (½ in) flat sable, using quick even continuous strokes across the base. I then allow the painting to dry thoroughly.

Using a size 00 nylon round brush with a very fine point and a mid-grey, I outline all the items. It is advisable to draw in the objects that stand above the back line of the table top slightly smaller, allowing for final adjustments if necessary, bearing in mind that the drawn lines will be covered at a later stage. Care should be taken when lining in the tulips. Once I have lined in the vase, tea caddy and fruit, I draw in the table top. When drawing in the outlines bear in mind that the boundary of the painting should be the inside line of your intended frame. Therefore you must use this boundary when balancing the picture.

Using a size 00 nylon round brush, I paint in the vase using a mid-blue mixed from titanium white, cobalt blue and ultramarine. I place dark lines around the upper portion. Now I paint in the oval design on the vase and the miniature painting on the wall: a very light blue is mixed from titanium white and ultramarine for the top portions of each; I paint in the lower portions

Stage 1

Stage 2

using light green oxide. These colours form the base for the two tiny landscapes.

I paint in the yellow ochre miniature frame and the oval frame around the vase design. Using brown mixed from burnt umber and ivory black, I paint in the tea caddy and add light edging and the keyhole plate. I paint the table dark brown, which is mixed from burnt umber and Mars black, and add a light table top edge. Using a mixture of raw umber and cadmium orange I paint in the orange and then place the apples and tulips with a neutral base, red and green. I now leave the miniature to dry thoroughly.

Stage 2

First I check to ensure the surface is clean and free from dust. I work on all the items in this miniature separately, starting with the tea caddy which is the farthest away in the group. I mix browns for this using titanium white, raw sienna, raw umber and Mars black, and paint them in showing light and shadow, leaving the detail work until a later stage. I work the blue vase next, mixing three shades of blue from titanium white, ultramarine and cobalt blue. I place the darkest shade on the areas in shadow: down the right side, to the right of the apple, and below the leaf on the left. I paint in the remainder of the vase using the lightest blue, painting over the dark lines around the top of the vase; these should remain just visible through the light blue. I

line in the edge of the oval exactly and use the mid shade of blue to blend in the other two shades of blue down the right side of the vase.

I mix a range of colours for the tulips, including the greens for the leaves, using dioxazine purple, quinacridone violet and red, titanium white, azo yellow medium, light green oxide, sap green and ivory black. I paint in the tulips exactly, adding all the details. It is advisable to work on the flowers to a finished stage, except for the highlights, while they are still fresh and before the blooms open further. I line in the leaves and paint them in more precisely. Next I mix the colour for the orange and paint it in indicating the shadows; I place the stalk and line in the area around the stalk.

I mix a number of shades from dark red to yellowish green for the apples, using naphthol crimson, quinacridone red, permanent green, cadmium yellow light and dioxazine purple. First I work on the apple on the right, placing the stalk and painting in the area of light greenish yellow around it. I shape up the remainder of the apple and blend it in using mid to dark reds, indicating the shadows. Then I work the other apple, painting in the core and blending it in with the greenish yellow. I place the red shadows. Finally a very dark brown is mixed from Mars black and burnt umber. This is used to place the shadows on the table top and below the table top edge. Now I allow the painting to dry thoroughly.

121

Stage 3 – the finished painting

I mix browns for the tea caddy and table using titanium white, raw sienna, raw umber, burnt umber, burnt sienna and Mars black. Then I shape up the tea caddy exactly and add the wood grain. I paint in the ivory keyhole plate exactly and place the two main highlights and also the highlights around the edges.

I strengthen the dark blue lines around the top of the vase with a mix of cobalt blue and Payne's grey, then place the highlights on the vase using a mixture of titanium white, ultramarine and cobalt blue.

I shape up the tulip leaves exactly and adjust the shading. With mixtures made from light green oxide, azo yellow light, sap green and Hookers green, I blend in the lighter colours and I add highlights to the tulips with a mixture made from titanium white, quinacridone red and violet.

Next I square up the miniature frame on the wall and paint it in exactly, using mixtures made from yellow ochre, cadmium orange and raw umber. I place the shadow to the right and below the frame using Mars black.

I strengthen the colour of the orange and blend in more detail around the stalk, then I place the highlights. Now I finish, adding detail to the apple on the right. I lighten the area around the stalk with a greenish yellow which is blended in and placed exactly. I brighten the red slightly and paint in the main highlights, also the smaller highlights around the stalk. Next I work on the apple on the left. I blend in light red on the left and around the core, and paint in the main highlight on the left and those around the core.

I square up the table showing the shadows exactly, by making the table top edge slightly lighter. I add the two small landscapes, working both together. Mixtures for the clouds are made from titanium white, yellow ochre, indo orange red, ultramarine and Payne's grey. I place the skylines and distances using light blues with a very pale green placed directly below. Using mixtures made from light green oxide and cadmium yellow I place the marsh greens on the oval, then paint in the water area on the rectangle using light blue. I place the path using light and dark fawns and green, and paint in the windmill using red, brown and white. I paint in the tree and reed beds on the rectangle using greens, yellows and browns and place the yacht using red and browns. Finally I make an overall check to see if any slight adjustments or alterations are required.

Stage 3 – the finished painting

122

Outline sketch

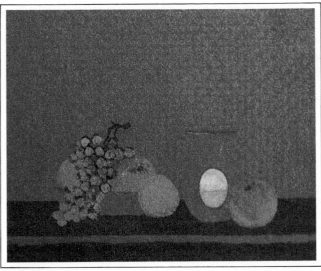

Stage 1

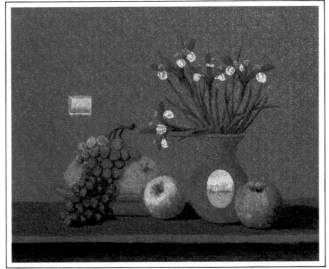

Stage 2

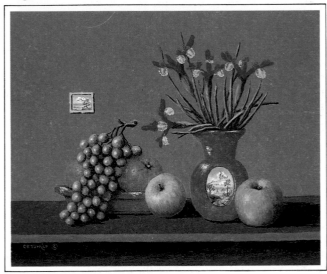

Stage 3 – the finished painting

Red glassware with fruit, flowers and miniature

Size: 7 cm × 8 cm (2¾ in × 3¼ in)
Base: Saunders mould-made HP paper on board

I do not go into any detail here with this still life study, as it is similar to the previous demonstration. The same principles and techniques are used to produce the finished miniature.

First I draw an outline sketch, then I apply the background colour, using a stippling technique, (see page 110), to produce an unusual colour blended wallpaper effect. Then I add the other items.

Follow the techniques in the previous demonstration using the stages shown here and complete the miniature.

Old coach inn, Norwich: demonstration

Size: 13 cm × 8 cm (5 in × 3¼ in)
Base: Saunders mould-made HP paper on board

Buildings make interesting subjects for miniature paintings. This coach inn is a simple subject, but it is possible to choose buildings that are extremely complex. It depends upon the amount of work you want to put into your miniature. I have chosen this subject because it is free from exact measured lines, which means the miniaturist can relax a little, and not be so precise in his approach. This, however, is not evident in the final painting where all the details are carefully painted in.

Stage 1

Using mid-grey and a size 00 round nylon brush, I draw in the outlines of the buildings, wall, pavements and tree trunks.

I mix a light blue for the sky using titanium white and ultramarine, and paint it in with a 1 cm (½ in) flat sable, using quick even continuous strokes across the base.

Next, I mix two shades of rust brown from red iron oxide and burnt umber, and paint in the roofs, chimney and wall. I use a mid-grey made from titanium white and Payne's grey to fill the end of the building on the left. Using two buff shades mixed from titanium white, yellow ochre and raw umber I paint in the inn walls.

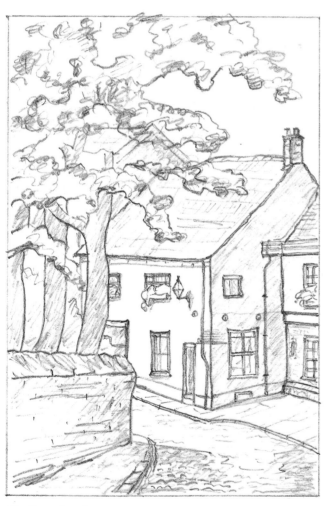

Outline sketch

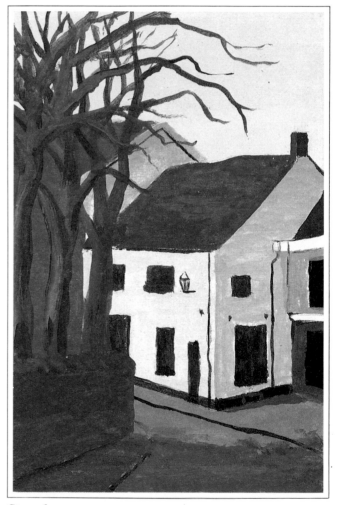

Stage 1

Using pink, I paint in the top portion of the building on the right applying a light cream strip above and below, then I paint in all the windows using Mars black.

To complete this stage I need to mix a number of light and dark greys using titanium white, raw umber, Payne's grey, burnt umber and Mars black. I use the lightest of these to fill the far pavement, and the darkest to fill the near pavement. I fill in the lower portion of the building on the right with a mid-grey and paint in the roadway which is not in shadow using a light brownish grey. Now I place the three tree trunks and main branches, painting them in with dark and mid-greys. I paint in the remaining areas with a mid-grey and leave the painting to dry thoroughly.

Stage 2

I mix a number of light to dark shades for the roofs, chimney and wall using red iron oxide, burnt sienna, raw umber, raw sienna, yellow ochre, olive green and Mars black.

First I work on the roof on the left, lining it up and blending it in. I line up the roof and chimney of the inn exactly and paint them in showing the basic details. I place the chimney pots exactly and then paint in the roof on the right and the wall showing the details.

Using a mid-buff grey made from titanium white, Mars black and yellow ochre, I paint in the gable end of the building on the left exactly and place the bargeboards with an off white.

I mix a variety of cream to buff mixtures using titanium white, yellow ochre, raw umber and cadmium red light, and paint in the walls of the inn, indicating the basic details and shadows.

Next I mix a number of light to dark browns and greys using titanium white, raw umber, Payne's grey, burnt umber and Mars black, and roughly place the details on the pavements and road, indicating the shadows. I paint in the area behind the trees more precisely and place the tree trunks and main branches more exactly, indicating the shadows.

I line up the lower portion of the building on the right and paint it in more precisely, indicating the shadows. I line up the top portion and paint it in using a mixture made from titanium white and quinacridone red.

Finally, I mix a range of light to dark greens using sap green, olive green, Hookers green, yellow ochre and cadmium yellow medium, and roughly place the foliage. I now leave the painting to dry thoroughly.

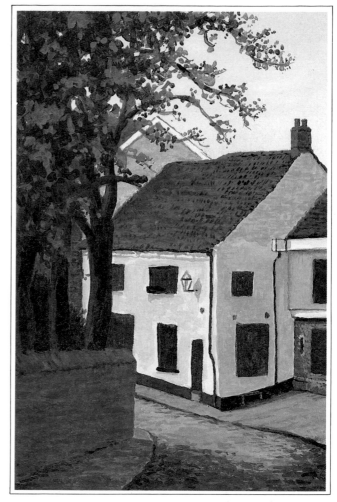

Stage 2

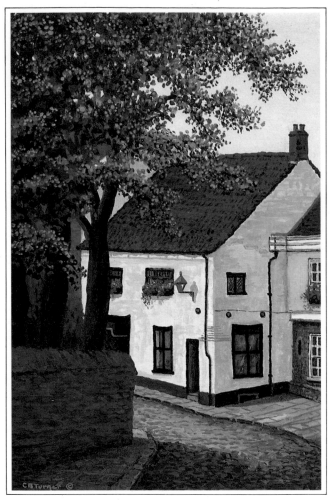

Stage 3 – the finished painting

I line and paint in the pavements exactly, and adjust the cobbled road for light and shadow, painting it in exactly. I adjust the lower portion of the building on the right exactly for light and shadow, and paint it in exactly, adding the brickwork. I make the top portion of the building lighter, and line the beadings in exactly. Using off-white I place the window frames.

I adjust and paint in the tree trunks exactly, extending the branches to fall in front of the inn roof.

Finally I mix a range of light to dark greens using olive green, sap green, permanent green, yellow ochre, azo yellow light and Mars black. I extend the foliage and paint it in exactly. Using greens, reds and yellows I paint in the window boxes.

I give the miniature a final overall check, and make any slight alterations or adjustments as required.

Medieval town wall tower

Size: 6 cm × 4.5 cm

Stage 3 – the finished painting

I make a variety of mixtures for the roofs, chimney and wall using red iron oxide, raw umber, burnt umber, cadmium orange, yellow ochre, olive green, Payne's grey and Mars black. I line up the inn roof and chimney precisely and place all the details exactly. I adjust the roof on the right slightly and place the lead edging using a mid-grey. I line up the wall precisely and paint it in showing all details, including the patches of moss.

I mix colour for the inn walls using titanium white, yellow ochre, raw umber and cadmium red light and line them up exactly, painting in the details and indicating the shadows and the underlying and corner brickwork.

Using mixtures made from Mars black, ivory black and burnt umber, I line up the inn windows, door frames, the downpipes, the circular support ends, the lamp and the black bottom surround and paint them in exactly.

I mix a number of light to dark greys and browns using titanium white, raw umber, Payne's grey, burnt umber, dioxazine purple and Mars black and paint in the inside of the inn windows exactly, placing in the reflections on the glass.

This beautiful old tower was built around 1287. It shows how by painting in miniature an old building can be isolated from its present day surroundings and given an atmosphere in keeping with its particular character and charm. If you are planning a subject like this, work out the composition in your sketchbook first.

Index

OTHER BOOKS PUBLISHED BY SEARCH PRESS

Painting in Oils
Edited by Michael Bowers

'This is a superbly illustrated book which I would thoroughly recommend . . . out of the hundreds of oil painting manuals which I have read, this is certainly one of the best.'
Mona Brinton, The Art Magazine

Painting in Watercolours
Edited by Yvonne Deutch

'A companion book to Painting in Oils . . . profusely illustrated with very fine demonstration watercolours . . . must be classed as excellent.'
Mona Brinton, The Art Magazine

Painting with Pastels
Edited by Peter D. Johnson

With full colour step by step demonstrations, five experts show how to use this fascinating medium in landscapes, flowers, portraits, still life, townscapes and animals.

Painting the Secret World of Nature

Four contributing artists demonstrate their interpretation of the secret 'hidden' world of nature; the fallen leaf, the budding flower or bulb; the tiny detail of undergrowth. Beautifully presented in full colour with over 30 step by step demonstrations.

The Technique of Icon Painting
Guillem Ramos-Poquí

With the aim of increasing the appreciation and understanding of the techniques used in icon painting, the author uses a selection of full colour Byzantine icons, accompanied by step by step instructions, to guide the reader through all the various stages.

Drawing for Pleasure
Edited by Peter D. Johnson

'. . . six authors who draw in different media and write about them with infectious enthusiasm. For fun in drawing, and some self-satisfaction in improving performance, this is ideal reading.' *The Leisure Painter*

Understand How to Draw Series

This series of 'how-to-draw' books is clearly written and illustrated with beautiful sketches and drawings by professional artists. Their aim is to encourage the reader – by providing a wide selection of examples in a variety of techniques – to develop his or her own skills and pleasure in the very broad field of drawing.

Leisure Arts Series

This popular, widely acclaimed series of oil, watercolour, pastel, gouache and acrylic teach-yourself-painting books, is written and illustrated by well-known artists. All the secrets of successful painting are explained with stage by stage full colour demonstrations and enlarged details of finished works.

Colour Calligraphy
David Graham

Using different coloured papers, inks and paints, David Graham illustrates simply and clearly how to use colour in calligraphy. This is a book that will inspire both the beginner and the more experienced calligrapher to experiment with different ways of using and applying colour.

Illuminated Calligraphy
Patricia Carter

Over forty illuminated borders for calligraphy are illustrated to inspire both the novice and more experienced calligrapher. Instructions and advice on the materials required, page layout, use of colour, the techniques of decorating letters and applying gold leaf are simply shown.

If you are interested in any of the above books or any of the art and craft titles published by Search Press, please send for a free catalogue to:
Search Press Ltd, Dept B, Wellwood, North Farm Road, Tunbridge Wells, Kent TN2 3DR